HOW TO PAINT
WATERCOLOUR LANDSCAPES

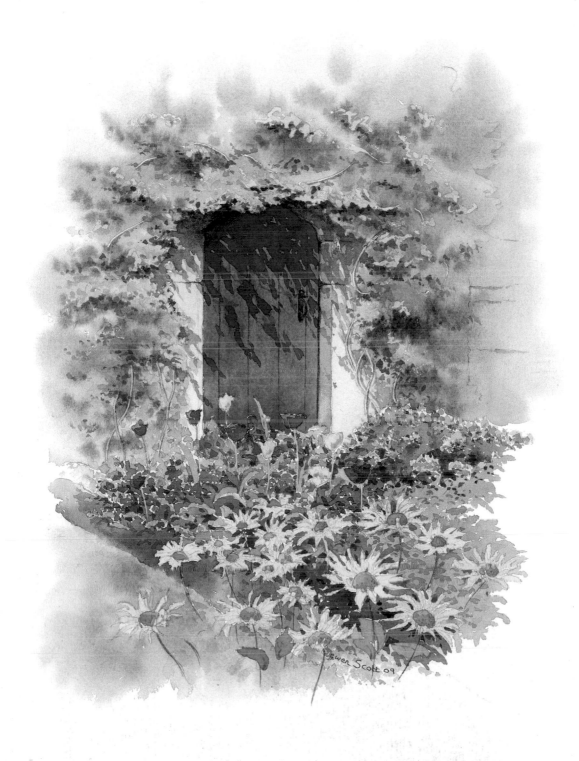

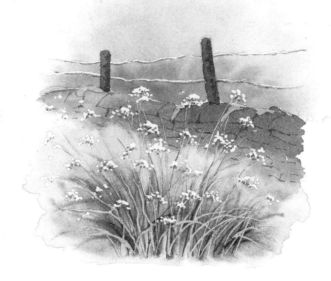

Dedication

*To my husband Andy for all
his love and support.*

HOW TO PAINT
WATERCOLOUR
LANDSCAPES

GWEN SCOTT

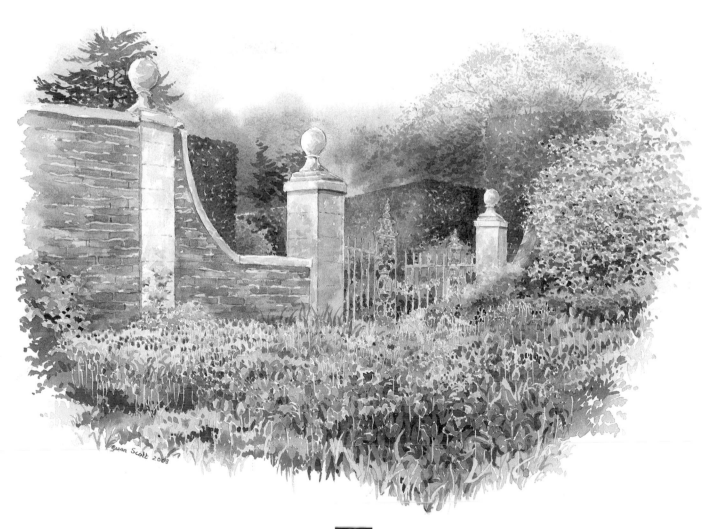

SEARCH PRESS

First published in Great Britain 2010

Search Press Limited
Wellwood, North Farm Road,
Tunbridge Wells, Kent TN2 3DR

Text copyright © Gwen Scott 2010

Photographs by Roddy Paine Photographic Studios

Photographs and design copyright © Search Press Ltd. 2010

ISBN: 978-1-84448-548-2

The Publishers and author can accept no responsibility for any consequences arising from the information, advice or instructions given in this publication.

Suppliers
If you have difficulty in obtaining any of the materials and equipment mentioned in the book, please visit www.winsornewton.com for details of your nearest Premier Art Centre.

Alternatively, please phone Winsor & Newton Customer Service on 020 8424 3253.

Publishers' note

All the step-by-step photographs in this book feature the author, Gwen Scott, demonstrating watercolour painting techniques. No models have been used.

You are invited to visit the artist's website at www.gwenscottwatercolours.co.uk

Printed in Malaysia

<div style="border:1px solid">

Acknowledgements

I would like to thank Roz for asking me to write this book and Sophie for her excellent editorial skills and guidance throughout the process of writing, and thanks to the rest of the team at Search Press.

</div>

Cover
Autumn River
43 x 33cm (17 x 13in)
This painting depicts my favourite season.

Page 1
Blue Door
33 x 25cm (13 x 10in)
I was drawn to the bright colours of the flowers which stood out against the striking blue door in this picture.

Page 2
Cow Parsley
15.2 x 12.7cm (6 x 5in)

This painting features in the section on masking fluid on page 27.

Page 3
Hidcote Manor Garden
43 x 33cm (17 x 13in)

A beautiful National Trust garden in spring displaying an abundance of brightly coloured tulips.

Opposite
Country Lane, Alstonefield
33 x 25cm (13 x 10in)

I enjoyed walking down this country lane in Derbyshire, knowing I would love to paint the scene later.

Contents

Introduction

I would like to emphasise the word colour in the title Watercolour Landscapes and show why I love to use this medium. The clean transparent qualities of watercolours are capable of producing the most wonderful vibrant results. Throughout this book I have included examples of my work to demonstrate how in my opinion watercolour pictures can have as much impact as acrylics or pastels. Alongside traditional green landscapes, I have used the yellows and browns of autumn, a sea of red across a summer poppy field and the beautiful purples and pinks of a lavender field to show how varied and diverse the colours of your palette can be.

It is very important to me that my paintings evoke memories, portray feelings and recreate the atmosphere of special places. We are fortunate nowadays to have the benefit of digital photography, and I always carry a camera which I use as my sketch book to help me record my inspiration. I don't try to take artistically complete photographs; I look to capture textures, patterns of colour that depict shadows, contrasting light effects and close-up details of foliage, water, and buildings. Occasionally I take separate elements from several photographs and combine them as references within one painting.

Throughout the book I have broken my paintings down into easy stages, showing how to simplify complicated looking pictures. For example, a large expanse of woodland may appear overwhelming to a beginner but rather than dismissing a scene because it looks too complicated, I advise always choosing a view that excites you rather than one that looks easy to paint.

The first section of the book is about choosing art materials and shows how to narrow down the vast choice available. This is followed by numerous tips on improving basic painting techniques in easy to follow stages. Knowing a little about colour mixing is important, and I show how to mix a wide range of colours from bright oranges and purples to subtle greys and natural browns from only a few tubes of paint. Finally, all these techniques are put into practice in two detailed demonstrations, a cottage scene and a colourful autumn lane.

I hope that you enjoy my book and that the exercises will help you to go forward confidently and paint your own special landscapes.

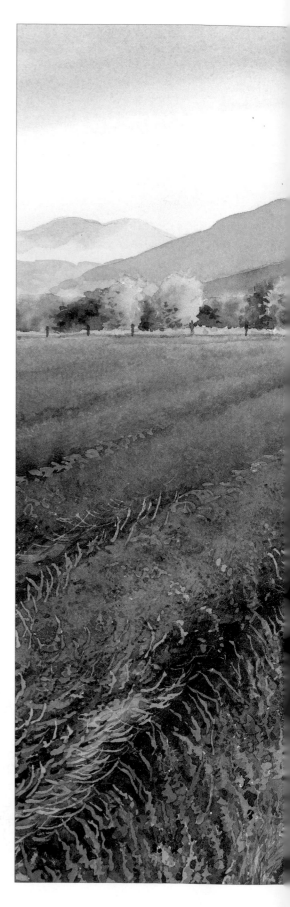

Lavender Field
46 x 33cm (18 x 13in)
It is lovely to see a field bursting with bright pinks and purples, a welcome change from the greens and browns usually associated with a landscape picture.

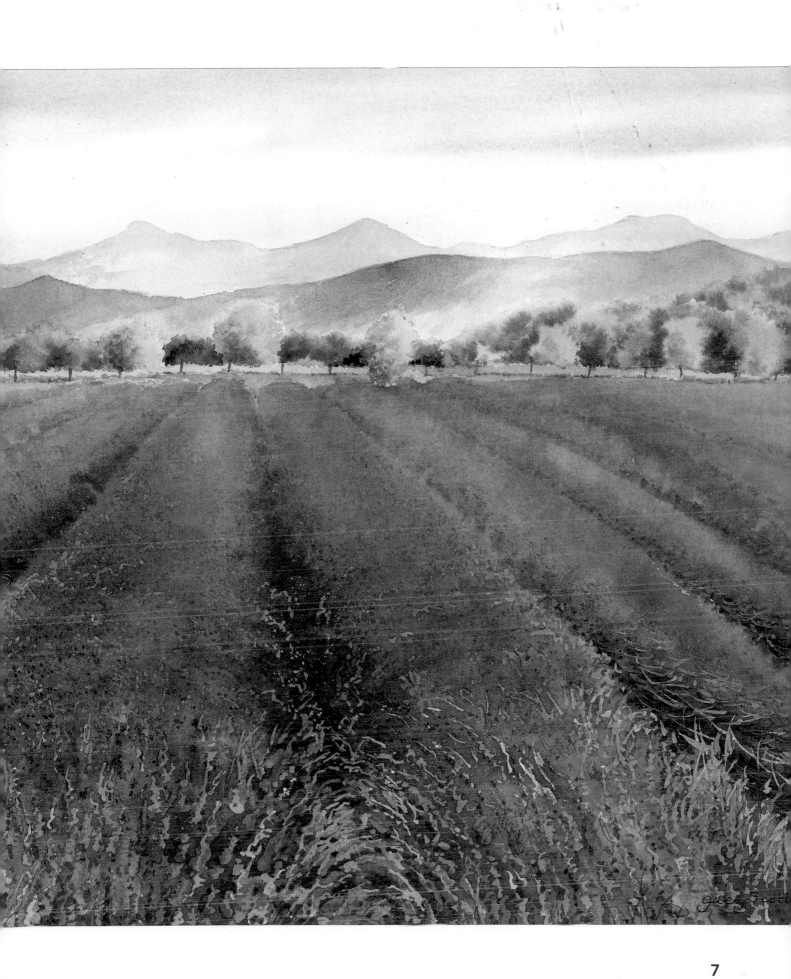

Materials

As a beginner in watercolours, unsure of what materials will be needed, it can be bewildering seeing the vast amount of art materials available in art shops or equipment catalogues. The following pages show the basic materials I recommend for beginners and the equipment I use to create my paintings.

Paper

Your choice of paper plays an important role in watercolour painting. There is a wide variety of differing sheet sizes, weights and surfaces available.

Paper comes in loose sheets, blocks or pads. I generally buy individual large sheets: 56 x 76cm (22 x 30in) in various thicknesses. I cut these into half or quarter sheets to suit the size of my painting.

A watercolour block is a pad of watercolour sheets glued around all the edges, making only the top sheet accessible. Removal of the finished picture exposes the next layer. The glued edging makes the block very rigid and therefore useful for painting outdoors. Stretching is unnecessary and it fits easily into a bag for carrying on location. I find small pads of watercolour paper particularly handy for quick coloured sketches whilst on location.

There are various weights (thicknesses) of paper ranging from 150gsm (72lb) up to 850gsm (400lb). The heavier the paper, the more expensive it is. I recommend 300gsm (140lb) upwards as thinner papers can buckle when wet. I prefer a paper with a 100% cotton rag content as this is very absorbent.

Loose watercolour sheets, a watercolour block and a pad for sketching.

Surfaces

There are three paper surfaces to choose from:

HP (Hot Pressed) A smooth paper, ideal for fine detail and painting flat washes.

Hot Pressed paper

Not (Cold Pressed) A medium textured paper, good for all styles of watercolour painting.

Not paper

Rough This has a heavier textured surface, ideal for loose, expressive brush strokes rather than fine detail.

Rough paper

Stretching paper

Watercolour paper needs attaching to a board prior to painting on it. This can be done whilst the paper is dry with masking tape around the edges. However, a smoother, flatter, more secure surface can be created by stretching the paper before working on it. The method for stretching paper is described more fully below.

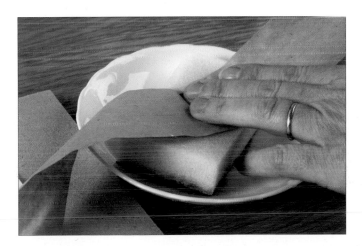

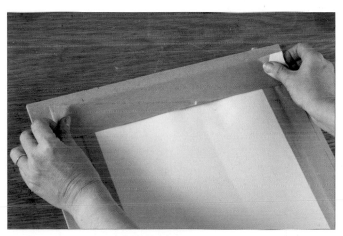

1 Wet the paper by soaking it in a bath of luke-warm water for three to five minutes. Shake off the excess water and lay the paper on your board. Run the damp sponge across the paper surface to remove any trapped air bubbles. Cut strips of gummed paper to the right length and wet the gummed side on a wet sponge as shown.

2 Position the gummed tape on the edges of your paper, with a quarter of the tape overlapping the paper. Stick it down and leave the paper to dry flat. As it dries, the paper contracts and is pulled flat by the gummed edges.

Paints

Watercolour paints come in either tubes or pans. Tubes contain a liquid paint, thick in consistency, which, once squeezed out into the palette, easily produces large quantities of vibrant colour. A pan consists of a hard block of dried paint which needs wetting with a brushload of water to release the colour. I find it is not easy to make the large amounts of deep colour required for large paintings with pans, so for this reason I prefer to use tubes.

There are two qualities of paint available, artists' and students'. The artists' quality comes in 5ml and 14ml tubes and are listed in a series 1–4, number 4 being the most expensive. These paints are higher quality than the students' range, they contain more pure pigment and the colours are more intense.

The students' watercolour range is available in 8ml and 21ml tubes and these are less expensive as they contain less pure pigment. This range is suitable for beginners who want to 'have a go'. Rather than buying a large box set, which usually contains a white and a black paint, I would recommend starting with a few basic tubes of Cotman Watercolours, as recommended on page 14.

I have tried several brands of watercolours but prefer Winsor & Newton artists' quality paints for my own paintings. The colours I have used throughout the book are: gamboge yellow, Winsor yellow, raw sienna, winsor red, cadmium red deep, light red, alizarin crimson, permanent rose, quinacridone magenta, winsor violet, ultramarine blue, cerulean blue, cobalt blue, indigo blue, burnt sienna and sap green.

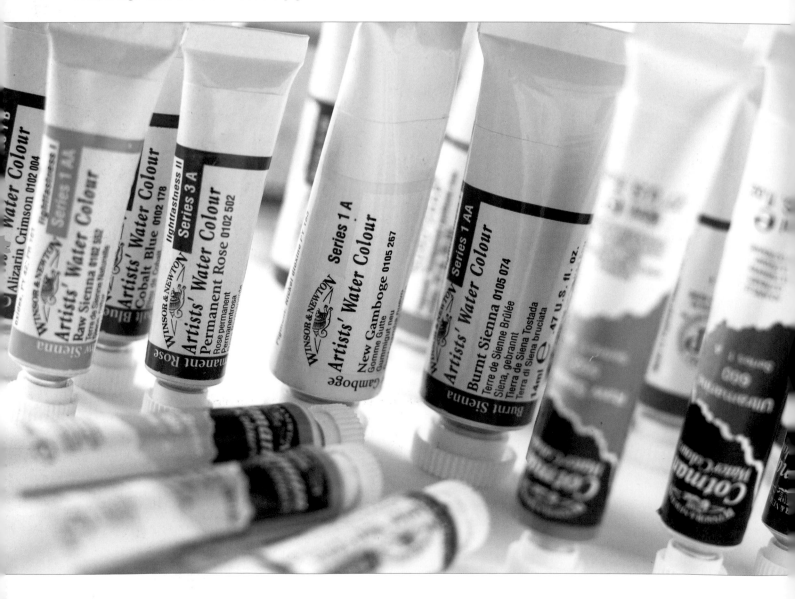

Palettes

Slantwell palette A small, six well, white plastic palette. This is ideal for beginners who have only a few basic colours. The small wells hold the neat (unmixed) paint and the larger areas are for mixing. I use this palette alongside the daisy mixing palette, displaying neat paint in all twelve areas.

The large rectangular white plastic palette This has more small wells for housing the neat paint, holding up to eighteen individual colours. The larger wells are for mixing the colours, and these can be easily and quickly wiped clean in between washes. The neat paint can be left to dry in the palette and revived by adding more neat paint on top of it. Occasionally the surface of the dried paints will need cleaning as other colours may have strayed on to them. Simply run the palette under the tap, gently passing an old brush across the colours. Thoroughly rinse the mixing wells at the same time. No detergent is needed to clean the palette.

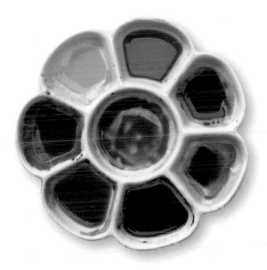

Daisy palette These are made of plastic or porcelain and come in different sizes. I prefer to use the porcelain ones as the brush seems to glide across the smooth surface, collecting more paint. The eight deep mixing wells hold the large quantities of paint needed for larger paintings. I keep this palette purely for mixing the colours, relying on the small plastic palette for holding the neat paint.

Brushes

Watercolour brushes are made from either synthetic fibres, natural sable or squirrel hair. Synthetic brushes are the cheapest and the Kolinsky sable brushes are the most expensive.

It is important that a brush holds a good quantity of colour, has a sharp point and springs back into shape between washes. I mainly use a brush with a synthetic and sable mix or a good quality synthetic brush. I prefer a round, pointed brush rather than one with a flat end.

Brushes come in sizes ranging from a tiny size 0000 to a large size 24. Always choose a brush to suit the size of area to be painted. A size 3 brush will not cover a large area without leaving unwanted brush strokes. To retain the shape and point, brushes should never be left sitting in the water pot.

There are a great variety of brushes available and this can be very confusing to a beginner. Only a few good quality brushes are needed to start with; a whole painting can easily be painted with only three brushes, a size 12, 6 and 1 round. In the two demonstrations starting on page 44 I have used only four brushes: sizes 12, 10, 6 and 1 round.

Occasionally I supplement my watercolour brushes by using a filbert brush made from hog hair. Traditionally used with acrylic or oil paints, its coarse, stiff bristles are perfect for stippling with the paint to produce the effect of foliage (example on page 23).

A synthetic round watercolour brush.

A synthetic/sable mix round watercolour brush.

A filbert hog brush, usually used for acrylics or oils.

Beginner's kit

Very little equipment is required to start painting in watercolours. The basic materials are listed below:

Cotman watercolours 8ml tubes Only a few colours are needed at first, as orange, purple, green, brown and black can be mixed from these four colours.

Gamboge yellow A fresh, transparent yellow.

Cadmium red deep A bright red.

Ultramarine blue A rich, deep blue.

Alizarin crimson A plum pink colour.

Sap green is also included in the list, only because I have used it for the basic exercise on trees on page 22 and the bluebell wood on page 24. I would usually advise starting with a green mixed from the yellow and blue.

A small plastic palette For laying out colours and mixing washes.

Round synthetic brushes with a good point, sizes 12, 6 or 7 and a no. 1.

A piece of **good quality cotton watercolour paper,** 300gsm (140lb), size 38 x 28cm (15 x 11in). I would recommend using good paper even as a beginner.

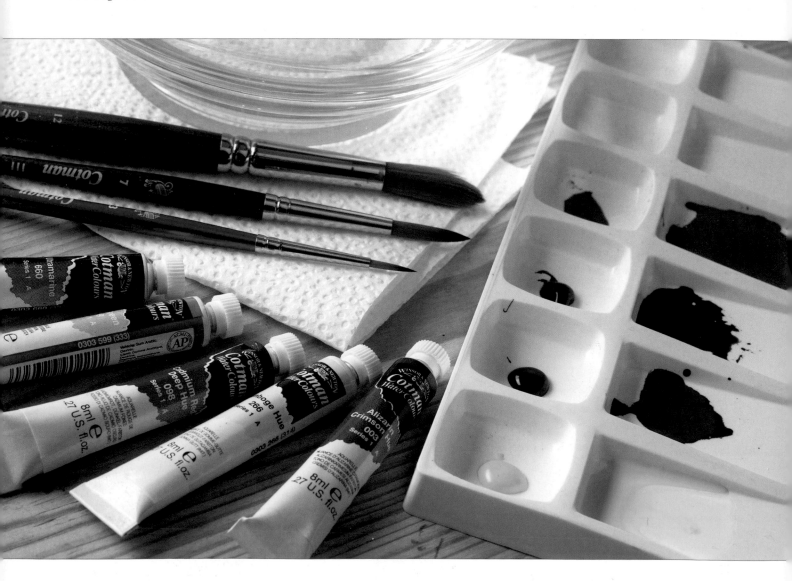

Other materials

Masking fluid is a latex-based liquid used to resist the painted washes so that you can retain areas of white paper. It is very effective for suggesting details such as tiny white flowers, blades of grass and flower stalks.

Ink pen This pen is normally for use with inks, but can also be used to apply masking fluid, creating very fine lines. The nibs are interchangeable and come in different sizes to create varying line widths.

Colour shaper This is also used to apply masking fluid, to create irregular shapes in larger areas, for example giving the appearance of clusters of white flowers.

Sponges are used for creating textures. Choose a natural sponge with varied ragged surfaces. If it is a large sponge, tear it up into smaller pieces, as these will be easier to work with.

Painting board A sturdy board is required to stretch the paper on. This is made from 5mm (¼in) MDF or plywood, and should be cut to a size 10cm (4in) larger than the paper.

Gummed tape is used to secure the wet paper to the board when stretching paper, as described on page 9. This gives a very professional finish, ensuring that the painting will dry flat and will not buckle as it dries.

Masking tape is used to attach dry paper to a board while painting. Because the paper is dry, you can work on it straight away, but this tape may start to lift if the paper gets very wet. Avoid tapes described as low tack as these are less sticky and more likely to lose grip on the paper, with the risk that the paper will buckle as it dries.

A **hairdryer** is used to finish the drying process, but should not be used until the painting is dry to the touch.

Pencil An HB pencil is used for drawing fine outlines.

Kitchen paper Dab the brush on this to remove excess water between washes and use it for wiping clean the mixing wells in the palette.

Water container This can be purchased at an art shop, but I prefer to use a large, round, plastic trifle bowl from a supermarket, as it holds plenty of water, is the perfect shape and has the added benefit of giving an excuse to eat more trifles!

Eraser I use a white plastic eraser.

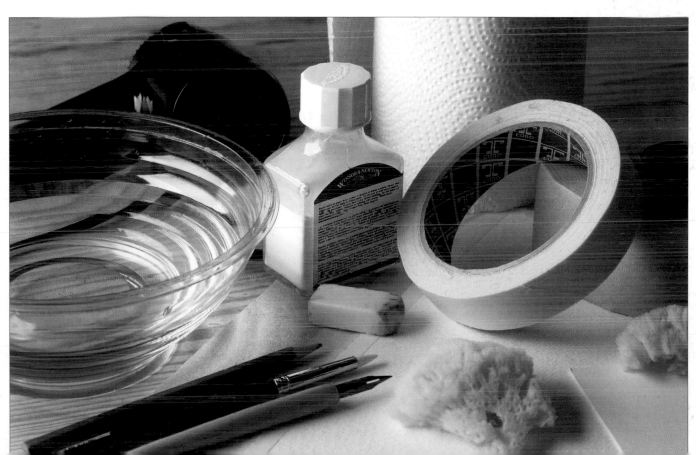

A water container, hairdryer, masking fluid, kitchen paper, masking tape, gummed tape, pieces of natural sponge, ink pen, colour shaper, pencil, plastic eraser and painting board.

Getting started

This section is for beginners in watercolours or for those who are struggling with the medium and want to go back to basics. It is important to have a thorough understanding of how the paint is diluted, mixed and applied before attempting a painting. The next few pages show how to make simple colour washes and the different ways of applying these by following simple step-by-step exercises.

The photograph shows how little equipment is needed to start painting in watercolours (items listed on page 14). Before we start we need to fasten the paper to the board, fill the water pot and prepare the palette of colours.

Setting up the palette

Squeeze out your chosen paint colours (an amount the size of a pea) into the small wells in the palette, using a separate well for each colour. On the tip of a damp brush, scoop up some paint and transfer it to the mixing well. Dip the brush into the clean water and stir this into the colour, gradually adding more water little by little. I prefer to add water to the paint rather than filling the mixing well with water, then adding the colour.

To maintain brilliant, fresh colours, regularly change the water and mix the colours on a clean palette. Now you are ready to start painting, I hope you enjoy it as much as I do!

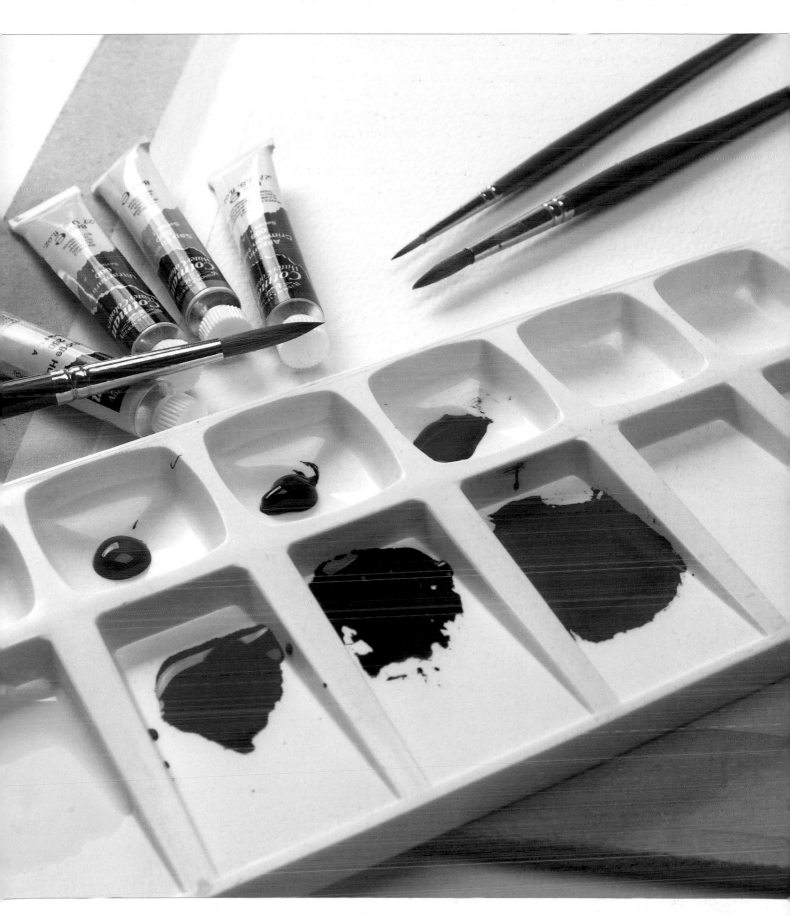

Basic techniques

There are two main techniques in watercolour painting: the use of flat washes and wet in wet. I will be referring to these throughout the book.

First set up the palette by squeezing out some gamboge yellow and ultramarine blue.

A flat wash

Using a size 6 brush, dip this into the water and then into the concentrated paint. Transfer some of the yellow into the mixing well and stir more water in gradually to create a fluid consistency. Fill the brush with the yellow wash and paint a 3cm (1¼in) square from left to right. If you can see brush marks, try again using a little more water in the mix. A larger wash requires a larger brush.

Move the brush from left to right, painting horizontal strokes, to achieve a flat, even wash.

To make the wash lighter add a little more water each time and paint a square, as shown below. You can water down other colours to make a range of pastel shades.

Gamboge yellow watered down progressively to create paler shades.

Layering flat washes

The reference photograph for the variegated leaf.

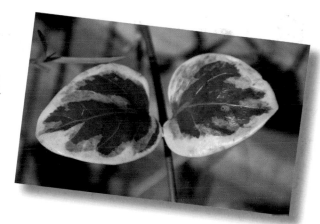

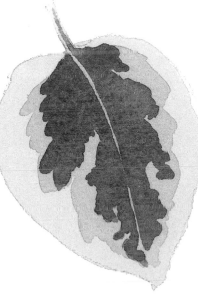

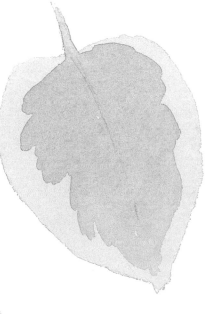

1 To paint this variegated leaf, draw the outline of the leaf on watercolour paper with two thin lines running down the centre to look like a vein. Mix a flat wash of yellow. Add a tiny amount of ultramarine blue to the yellow wash and stir this in, then add more water to lighten the colour. Test the colour on a sheet of scrap paper. Keep filling up the brush with the yellow wash and paint the leaf from top to bottom. Leave to dry.

2 Add a little more blue to the yellow wash and stir this in. Paint this green wash in the centre of the leaf. Leave this to dry.

3 Make a dark green by adding slightly more blue. Paint this either side of the pencil lines to give the effect of a vein.

Wet in wet

This technique involves adding wet paint into a wet wash of colour or into clear water on the paper. This is referred to as 'dropping in the colour'. The following exercise outlines this method of painting in easy stages.

Wet in wet is a most exciting and challenging technique. The results can be very unpredictable and at times it feels like the paint has a mind of its own. If overworked, the colours can become muddy, but with practice this method of painting produces some beautiful results as one colour merges into another.

Wet in wet squares

Practise the wet in wet technique by painting simple squares before moving on to more complicated leaf shapes. Wet a square with a brush load of water and paint in a colour with a no. 6 brush. Watch the paint spread across the square. On another wet square, try dropping in two colours side by side. Next, paint a flat wash of yellow and paint in some blue before the yellow dries – the blue mixes into the yellow and turns green. Experiment with different brush strokes and colours, allowing one colour to run into another across the wet surface.

A wet in wet leaf

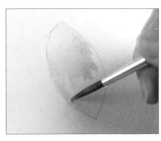
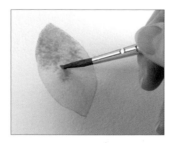
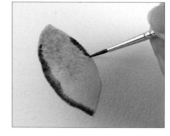
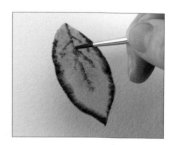

1 Draw a leaf shape. Using a no. 6 round brush, paint a flat wash of new gamboge.

2 While the yellow wash is still wet, drop in sap green at the top of the leaf.

3 While the underlying wash is wet, use the no. 2 brush to dot in a thick mix of alizarin crimson around the edges of the leaf.

4 Still working into a wet background, paint veins with the alizarin crimson.

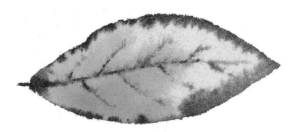

The finished leaf.

Autumn leaves

The deep rich colours of autumn leaves are perfect reference material for practising the wet in wet technique. Lightly pencil in the shapes of the leaves and mix all the colours in the palette before starting. The colours always dry lighter than when first applied so add plenty of paint to each wash.

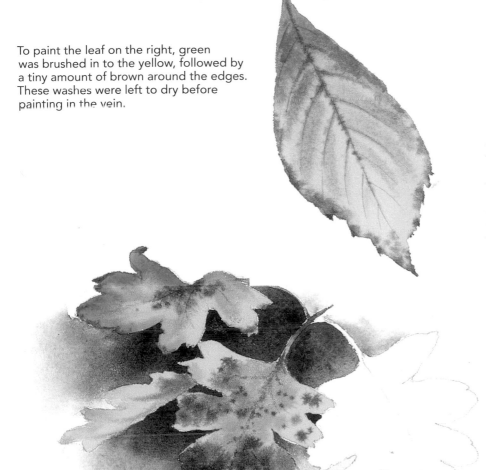

To paint the leaf on the right, green was brushed in to the yellow, followed by a tiny amount of brown around the edges. These washes were left to dry before painting in the vein.

In this leaf (right) I dropped the individual colours red and green into a yellow wash. Instead of mixing a dark brown in the palette, I painted in a little blue on top of the red and yellow at the edges of the leaf, allowing the colours to mix on the paper.

Painting a dark green background for these oak leaves emphasises the yellow edges of the leaves.

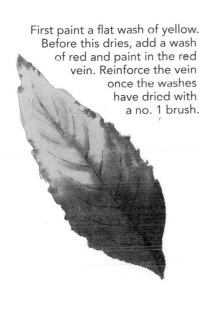

First paint a flat wash of yellow. Before this dries, add a wash of red and paint in the red vein. Reinforce the vein once the washes have dried with a no. 1 brush.

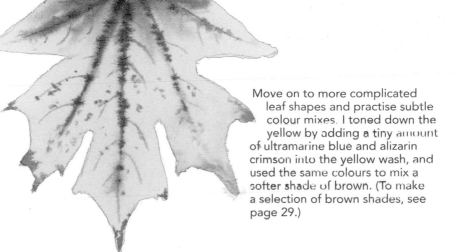

Move on to more complicated leaf shapes and practise subtle colour mixes. I toned down the yellow by adding a tiny amount of ultramarine blue and alizarin crimson into the yellow wash, and used the same colours to mix a softer shade of brown. (To make a selection of brown shades, see page 29.)

Sponging

One dab of a textured sponge dipped into the paint rapidly produces the same effect as that created by twenty fine paint brush strokes. The irregular patterns produced resemble the clusters of tiny leaves ideal for tree foliage. Remember to mix plenty of colour before starting, as the sponge soaks up large quantities of paint.

1 Dip a natural sponge into a wash of sap green in your palette.

2 Dab the sap green paint on to your watercolour paper to create a texture. Leave this to dry.

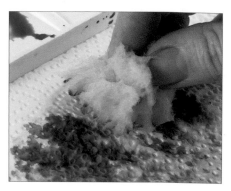

3 Before moving on to another colour, dab excess paint off on to kitchen paper.

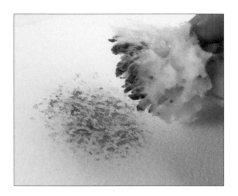

4 Add a little ultramarine to the sap green wash in your palette, pick up this darker green on your sponge, and apply it on top of the first layer of sponging.

5 After dabbing off excess paint as before, add more ultramarine to the mix and sponge this darker green on top of the previous layer.

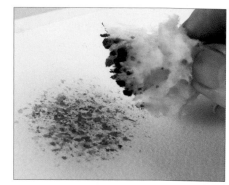

A sponged tree

Paint this simple tree by following the steps below. Always keep in mind the overall shape of the tree that you want to paint, leaving tiny gaps of white paper in between the foliage to give a more realistic effect. This tree painting is actually 7.5 x 10.5cm (3 x 4in).

1 Always paint the leaves before the trunk, as a yellowy green colour will not cover over a dark brown. Apply sap green with a sponge as shown above. Allow to dry.

2 Add ultramarine to the mix to make a darker green and apply this with the sponge on top of the dried sap green, creating the shaded areas of foliage. Allow to dry.

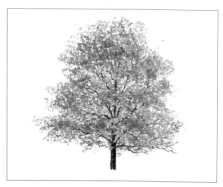

3 Paint the trunk with the no. 1 brush and a mix of ultramarine blue and burnt sienna, working from the base upwards, with a broken line. Leave gaps to give the impression of leaves growing in front of the trunk. Finish off by placing some fine branches in the white spaces.

Stippling

Another way of painting trees is to stipple the paint using a hog hair brush. Traditionally this brush is used for acrylics or oil painting, but when used with watercolour, the coarse bristles separate when dabbed on the paper to leave a textured mass of colour. This effect is not achievable with a soft watercolour brush.

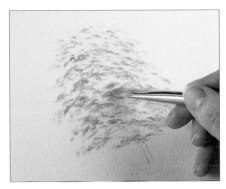

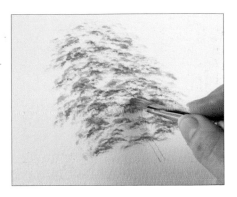

1 Draw in the basic trunk and branches, then take a filbert hog hair brush, pick up a mix of new gamboge and ultramarine on the tip of the brush and dab it gently on the paper to create the texture of foliage. Allow to dry.

2 Add a touch more ultramarine to the mix and stipple on this slightly darker green. Allow to dry.

3 Add still more ultramarine to the mix and stipple on the darkest green.

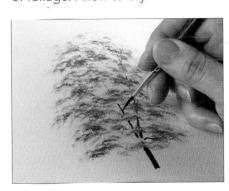

4 Mix ultramarine with burnt sienna and paint the trunk with a no. 1 round brush. Paint branches too, leaving gaps for foliage and always painting from the bottom upwards.

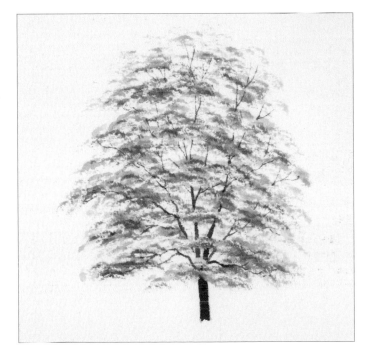

The finished tree.

Paint this simple hedgerow by stippling different shades of green with the hog hair brush. To maintain the flat edge of the field, cover over the dry painted field with a piece of paper to protect it whilst stippling the hedge.

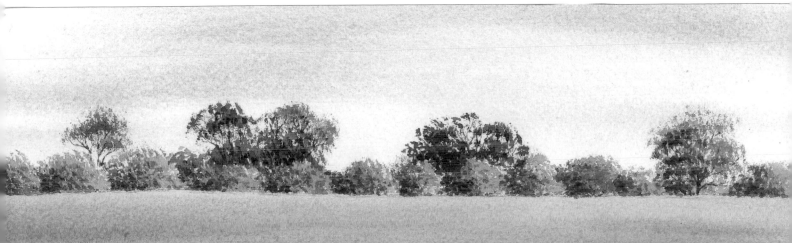

Combining sponging and stippling

New spring growth produces clusters of vivid yellowy green leaves. Foliage is much brighter at this time of year and springtime is the only season where I use the intense colour of sap green in an English landscape. Rather than painting each individual leaf, I have suggested the effect of foliage in an overall wet-in-wet wash. This is followed by sponging and stippling to define the textures and details of the leaves and bluebells.

Bluebell wood using sponging and stippling

Colours used: sap green, gamboge yellow, cobalt blue, burnt sienna, ultramarine blue and permanent rose.

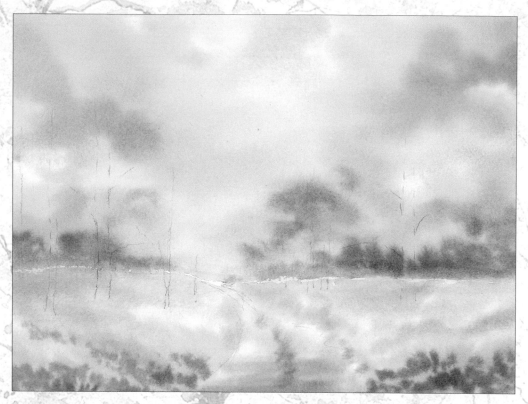

1 Lightly draw in the horizon line, the curve of the path and the bottom third of the tree trunks. Make large washes of yellow, sap green, a yellow and sap green mix, a pale wash of cobalt blue and a deep mix of ultramarine with yellow for a dark green. Wet the paper with a no. 12 brush down to the horizon line, then wet it again. Painting wet in wet, start by painting in the yellow to form the tops of the trees with the large brush. Add washes of yellow-green and sap green, filling in areas of pale blue for the sky. Finally, drop in the deep green mix just above the horizon line, and leave to dry.

Make two watery shades of lilac by mixing permanent rose and cobalt blue in differing quantities, producing one colour which is more pink and the other more blue. To make the pale colour for the path, mix ultramarine blue, permanent rose and yellow, using plenty of water. Wet below the pencil line and paint in the lilac washes first, then, using the foliage greens, indicate the grassy areas. Next, paint in the path. Make sure that the lilac colour and the greens are both painted on to the white of the paper and not overlapped otherwise the colours will turn muddy. Leave to dry.

2 Dip the moist sponge (as shown on page 22) into a wash of yellow and lightly apply this colour over the tree area. Sponge on the greens from light to dark, leaving each layer to dry before moving on to the next. Switch to the hog hair brush and stipple on some darker greens to give the impression of shadows under the leaves.

Wash the sponge thoroughly before changing from green to lilac colours. Sponge the bluebell area with the two lilac washes and green for the grassy banking at the bottom corners.

Mix ultramarine and burnt sienna to make a dark brown. Using a no. 1 brush, paint in the tree trunks, starting at the bottom then working up the tree. Leave gaps in the brown to suggest that the leaves are growing in front of the trunk as shown in the finished painting. Paint in a few fine branches.

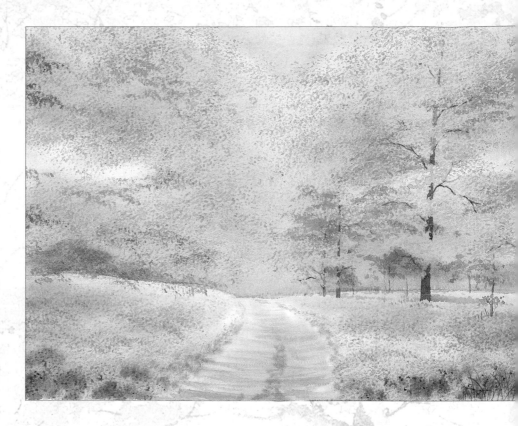

3 Paint in all the tree trunks, making some of them smaller and thinner towards the centre so that these look as if they are receding. Paint in their cast shadows across the bluebells. Create areas of shadow over the bluebells by applying deeper lilac washes below the trees using a number 6 brush. Paint the dappled shadows across the path by overlapping layers of the previously mixed path colour.

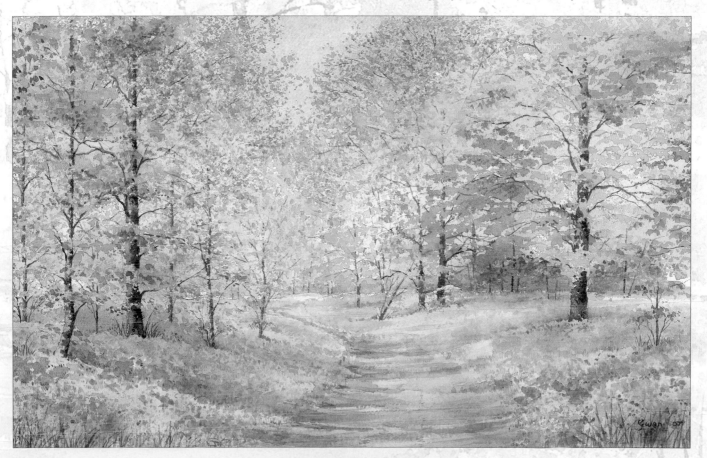

Masking fluid

Masking fluid resists the paint, leaving white areas of the paper once it is removed. This simplified study shows how to apply it to emphasise fine, pale grasses and white flowers in front of a dark wall. The finished painting is also shown on page 2. This is more effective than using white paint for the delicate flowers.

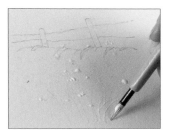

1 Draw the scene. Use a no. 2 taper head colour shaper to apply masking fluid to the cow parsley heads and to highlights on the wall.

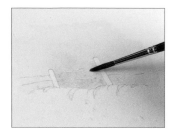

2 Use an ink pen to apply masking fluid to the grasses and the wire. Allow to dry. Mix three green washes from new gamboge and ultramarine: a yellow-green, a mid-green and a thicker dark green.

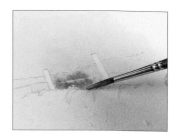

3 Wet the area above the wall with clean water, leaving the posts dry. Drop in the yellow-green with a no. 6 brush, painting round the posts.

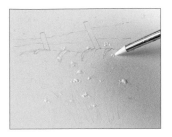

4 While this wash is wet, drop in the mid-green at the bottom of the green area, near the wall. Allow to dry.

5 Wet the grassy area, leaving the wall dry. Drop in yellow-green.

6 While this is wet, drop in mid-green, making vague grassy shapes with the brush.

7 Use the no. 1 brush to paint grasses wet in wet with the thicker dark green mix.

8 Make two mixes of ultramarine, cadmium red and new gamboge; one browner and one bluer. Using the no. 6 brush, paint parts of the wall using each mix.

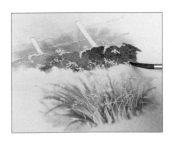

9 Continue building up the wall in patches of the two mixes.

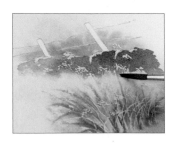

10 Use a damp, clean brush to merge the wall with the grassy area.

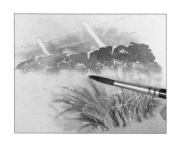

11 Add more yellow-green to the top part of the grass. Allow to dry.

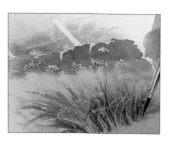

12 Use the tip of the no. 1 brush to add grasses in dark green. Allow to dry.

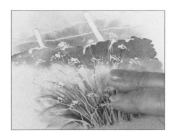 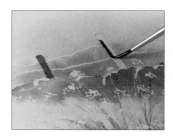 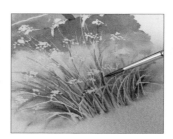 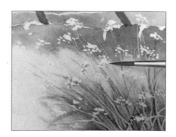

13 Rub off the masking fluid with clean fingers.

14 Paint the posts with the no. 1 brush and burnt sienna and ultramarine. Allow to dry.

15 Fill in the masked grasses with yellow-green.

16 Dot mid-green under the masked flower heads to highlight the white.

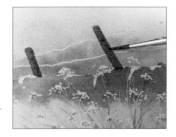 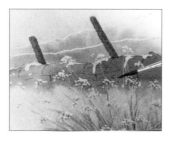 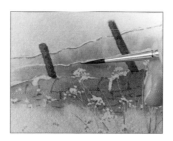 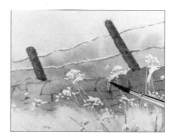

17 Add shadow to the posts with a darker mix of burnt sienna and ultramarine.

18 Use the point of the brush and the same mix to paint cracks in the wall.

19 Paint shadow under the wires in the same way.

20 Water down the browner mix used for the wall and paint the highlights in the wall.

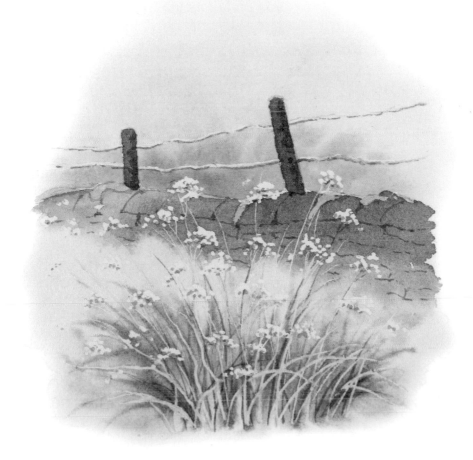

The finished painting.

Colour

Knowing a little about colour theory will improve your paintings. Painting a colour wheel will show you the variety of colours that can be mixed with the three primary colours: red, blue and yellow. These three colours are the basis for every other colour on the colour wheel; from these we can make colours that harmonise with each other throughout a painting.

Make your own colour wheel

Use gamboge yellow, cadmium red deep and ultramarine blue.

1 Draw twelve 3cm (1¼in) numbered squares on watercolour paper in a circle like a clock face.

2 Make a flat wash of red, one of yellow and one of blue.

3 Using a no. 6 brush, paint yellow in square 12, red in square 4 and blue in square 8. Remember to clean your brush and dry it on a paper tissue in between squares to keep your colours fresh.

4 With the tip of the brush, transfer a tiny amount of red from the neat paint in the palette to the yellow wash (make more yellow if necessary) and make yellow-orange. Paint this in square 1. Add more red to the mix to make orange. Paint this in square 2. Add more red to make red-orange. Paint in square 3. (Test the colours on a piece of spare paper.)

5 Make a new wash of yellow and with the tip of the brush, transfer a tiny amount of neat blue paint to the yellow wash. Mix this in to make yellow-green. Paint this mix in square 11. Add a little more blue to the mix to make green, and paint square 10. Add more blue to make blue-green, and paint square 9.

6 At this stage I have substituted alizarin crimson for the red, as this makes a more vibrant violet. Make a wash of alizarin crimson and add a tiny amount of blue, and mix these to make red/violet. Paint this wash in square 5. Add more blue to the wash to make violet, and paint square 6. Add more blue to make blue-violet and paint this in square 7.

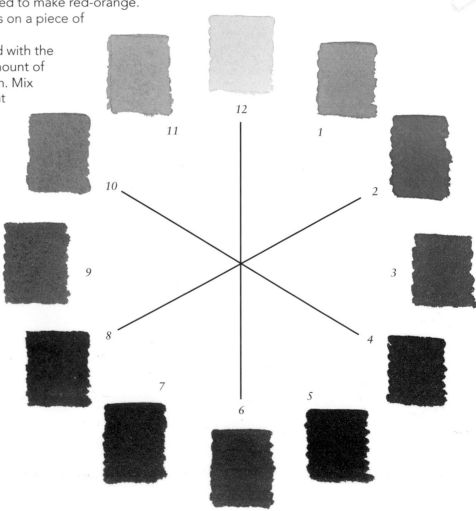

Mixing natural browns

A variety of brown shades can be made by mixing opposite colours on the colour wheel, for example, mixing violet and yellow, blue and orange, green and red.

Violet into yellow

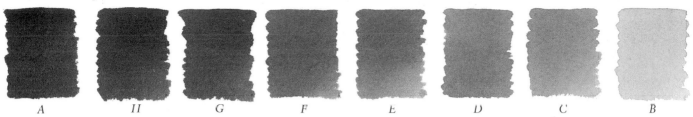

| A | H | G | F | E | D | C | B |

1 Draw eight squares in a line on watercolour paper.
2 Make a wash of violet by mixing ultramarine blue with alizarin crimson. Make a wash of yellow.
3 Paint violet in square A. Paint yellow in square B.
4 On the tip of your brush transfer a tiny amount of violet into the yellow and mix together. Paint this mix in square C.
5 Add a little more violet to the yellow-brown mix, stir this in and paint square D. The wash should slowly be turning brown.
6 Continue adding a little more violet into the brown wash, then paint individual squares E, F, G and H, creating deeper shades of brown each time. If the mix is turning green instead of brown, this is because the violet mix has too much blue in it. Also if the colours are drying too pale, try again, adding more pigment.

Green into red

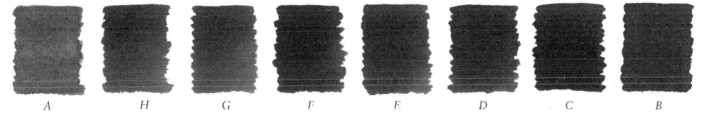

| A | H | G | F | E | D | C | B |

Green (a mix of blue and yellow) is added to red slowly using the same method as above to create rich, dark browns.

Blue into orange

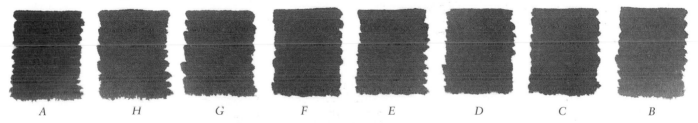

| A | H | G | F | E | D | C | B |

Blue added slowly into the wash of orange (a mix of red and yellow) makes another set of browns.

Mixing natural greys

Rather than using a harsh black straight from a tube, you can create more natural looking greys as follows. Make a black mix from ultramarine, alizarin crimson and gamboge yellow, then water this down to make different shades of grey. This grey mix is shown below and was used in the sky on page 35.

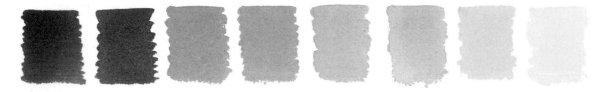

Painting a scene using greys

Create the misty scene of Bircham Windmill shown below using a variety of greys made from a mixture of just two colours, ultramarine blue and light red. Ultramarine is added to a wash of light red a little at a time, gradually turning this into shades of grey as shown in the line of squares. To start the painting, mix up a grey wash using only a small amount of light red mixed into the blue. If the mix turns brown, add more blue.

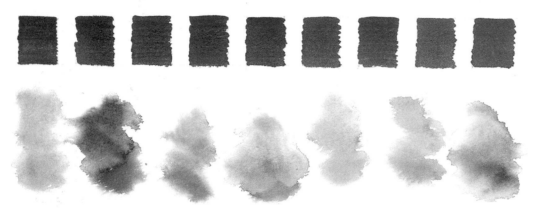

Thoroughly wet the paper above the horizon line and drop in the grey mix, wet in wet to create the clouds. Paint a deeper shade of grey using a thicker mix by adding more blue for the bushes. Leave to dry. Wet the bottom half of the picture and paint a brown-grey wash in lines depicting the furrows vanishing into the distance. Paint the windmill and other detail on the dried background.

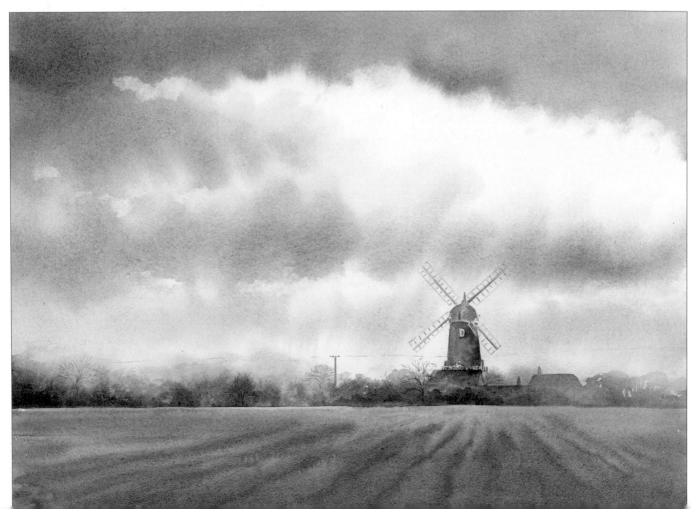

Mixing greens

This is a very green picture, so it is important to fill it with a variety of contrasting shades to emphasise a feeling of depth in the painting. I have included a grey-green to suggest distance, a bright yellow-green to indicate the grass, and exaggerated rich, dark greens for bushes and shadows.

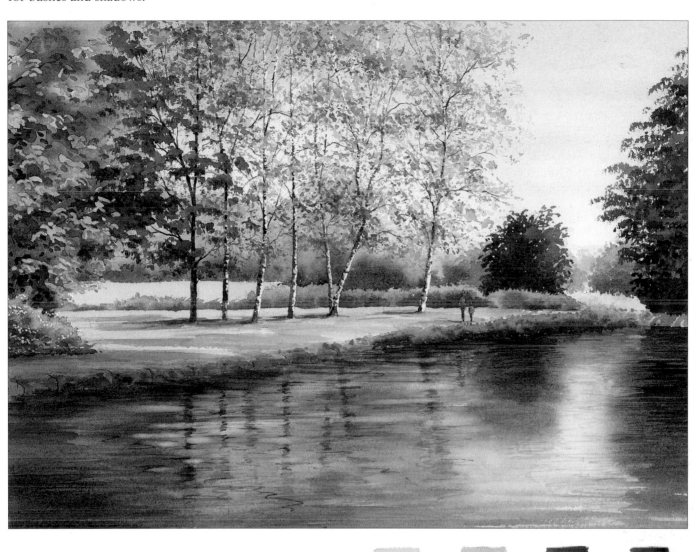

The colour swatches show the different shades that can be mixed from combining a variety of yellow and blue paint rather than using a ready-made green from a tube. I have mixed different combinations of either ultramarine, cobalt or indigo blue with Winsor yellow, gamboge yellow or raw sienna to make a variety of greens, which were used in the painting above. To make a strong dark green, add very little water to the mix and use plenty of blue. Pale distant greens need a lot more water in the mixture.

Complementary colours

At times watercolour can be such a challenging medium. For example, complementary colours (opposites on the colour wheel) cannot be placed on top of each other or overlapped without the colours merging and turning brown as shown in the examples below.

Red and green painted wet in wet make brown.

Painting red on top of green makes the red look dull.

Using red and green side by side

The complementary colours red and green of the poppy field need to be painted side by side on to the white paper to maintain fresh, vibrant colours. There are two ways of doing this: the first is to paint all the red flowers and carefully paint in the green around each flower. The second method is to mask out the poppies then paint a green wash over the top. In the large painting on page 35 I found it more effective to use the second method because of the vast number of flowers it contained. A close-up detailed section of the painting is shown below.

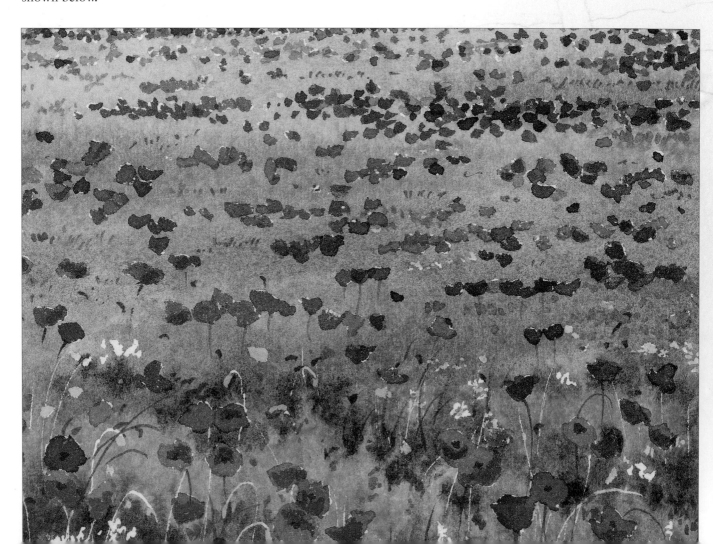

Masking out poppies

The second method of using red and green side by side is to mask out the poppies then paint a green wash over the top, as shown in this demonstration.

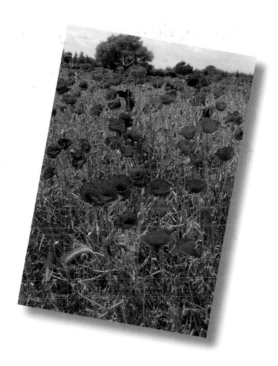

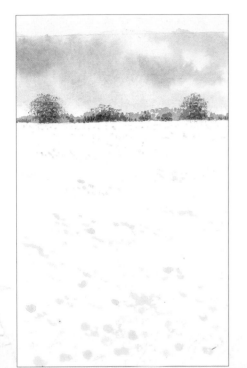

1 Paint a simple sky and distant trees. Mask out the poppies using the tip of a colour shaper, starting with the distant poppies, then gradually enlarging the flowers in the foreground, painting them in clumps rather than straight lines. The masking fluid needs to be applied carefully to resemble the shape of poppy heads rather than circular blobs. Use a fine pen (as shown on page 15) to mask out grasses, buds and a few tiny white flowers.

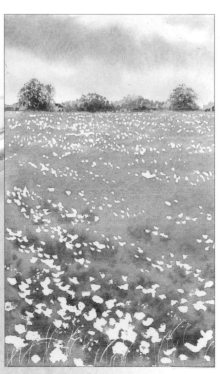

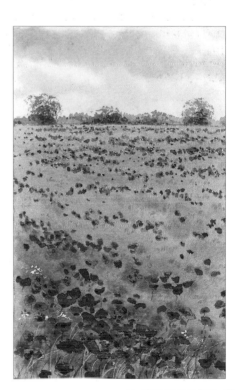

2 Leave this to dry, then wet the poppy field area. Paint a wash of yellow-green in the distance working down to the bottom with a mid-green, then drop in a deep green around some of the larger flower heads. I used Winsor yellow and ultramarine blue for the green washes.

3 Leave this to dry thoroughly then rub off the masking fluid. Paint in the flowers with Winsor red and the stalks and grasses with yellow-green.

Composition

When I came across this wonderful poppy field with Burnham Windmill in the distance, I knew I had to capture every detail with my camera. I took about fifty photographs from every angle. From these photographs I had enough information for several different paintings.

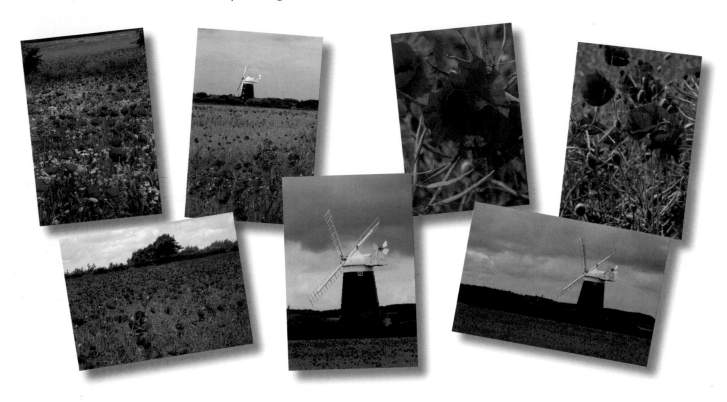

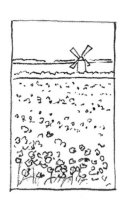 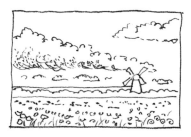 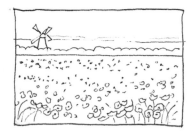

Thumbnail sketches

Making small designs called 'thumbnails' helps to quickly work out the different compositions for your paintings. Whilst doodling these sketches, we can consider how high or low the horizon line is, if the painting would look better vertical or horizontal and where the focal point should be.

The rule of thirds

A traditional approach to composition is to use the 'rule of thirds'.
The picture is divided into thirds horizontally and vertically and the main
feature, or focal point, in this case the windmill, is positioned on one of the
points where these lines cross rather than in the centre of the painting.

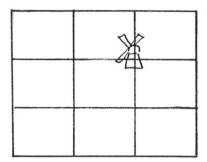
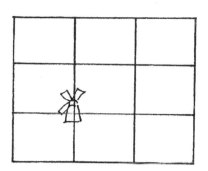

I placed the windmill along the bottom third of the picture and balanced the
empty space to the left with a dark cloud. I also placed a dark cloud around the
sails to make them stand out once the masking fluid was removed.

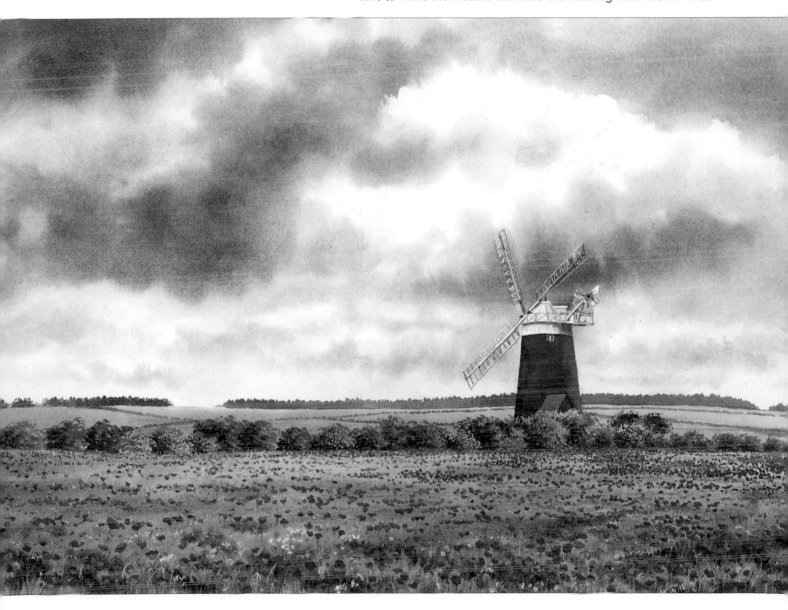

Worksheets

Whenever I come across a subject that I have not painted before, or a scene with a different set of colours or textures, I always make a worksheet before starting a painting. I use the sheet to plan the overall colour scheme and try out different techniques to capture certain textures or effects. I learn a lot from doing this, always making notes and labelling colour mixes in case I want to paint a similar picture at a later date. I now have a vast collection of worksheets that I use for reference and I still record the colours used on every new painting. It is impossible to remember the hundreds of colour combinations that have been mixed from all the paints I own so I find my colour swatches invaluable. When I teach a workshop, I advise my students to make a worksheet alongside their painting, to remind them of the colours and techniques used on the day.

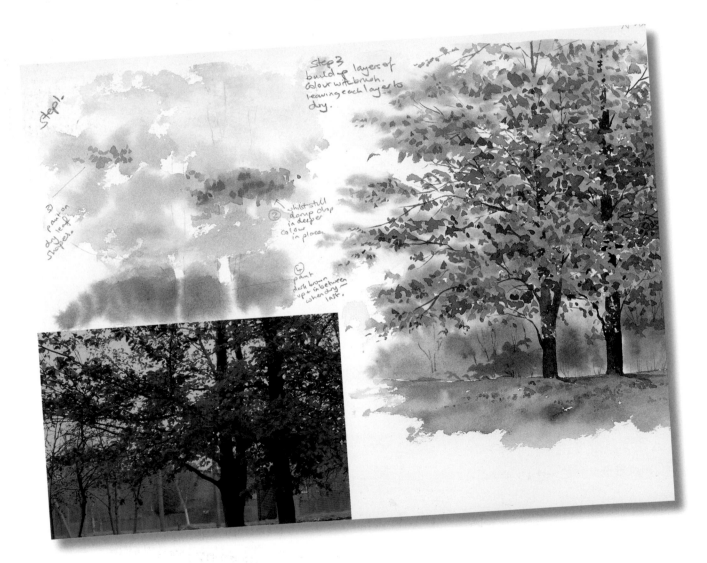

Autumn trees
Here I practised making the orange-red leaves stand out from the dark green background without the colours turning muddy.

Lavender field

It was important to practise achieving the colours of the lavender before starting. I chose three different pinks, a violet and two blues. I painted small colour swatches of each one then mixed them in different combinations until I was happy that I had found the right shade for the flowers and their shadows. I practised merging these colours wet in wet to assess the overall effect before painting this area on the finished picture. The completed painting can be seen on pages 6–7.

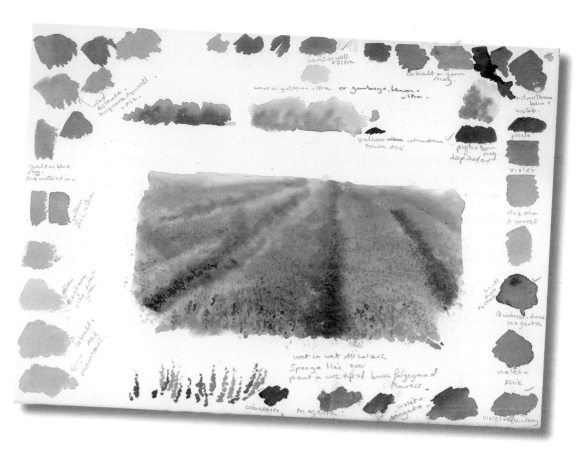

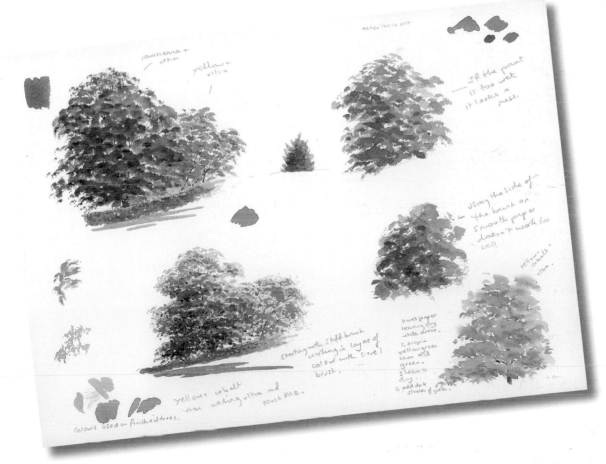

Trees

This sheet records the different techniques used to paint trees and their individual green shades.

Placing flat washes side by side

In the painting **Bluebells at Kedleston Hall** (opposite, bottom), I have painted decorative brush strokes of lilac and green next to each other to give the impression of flowers and leaves. The patterned flat washes are carefully painted side by side across the whole picture, a bit like filling in the pieces of a jigsaw puzzle. When a section of the painting is taken in isolation (see the two details opposite), the patterned brush strokes of colour, taken out of context, form an abstract picture. It is interesting to see how the colours and shapes interact with each other.

My pictures of a **Blue Door** (page 1) and **Hidcote Manor Garden** (page 3) also include the technique of painting patterned flat washes side by side on dry paper. Detailed samples from these paintings are shown below.

Apart from the pleasing decorative effect, a good reason for painting in this way is to avoid the complementary colours overlapping, mixing on the paper and turning brown.

Detail from Blue Door, page 1.

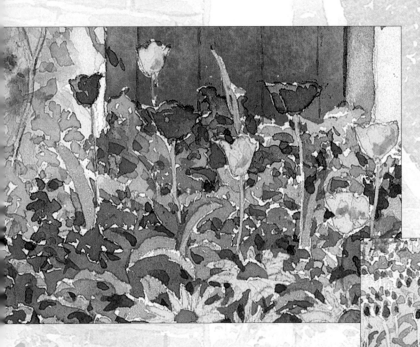

Detail from Hidcote Manor Garden, page 3.

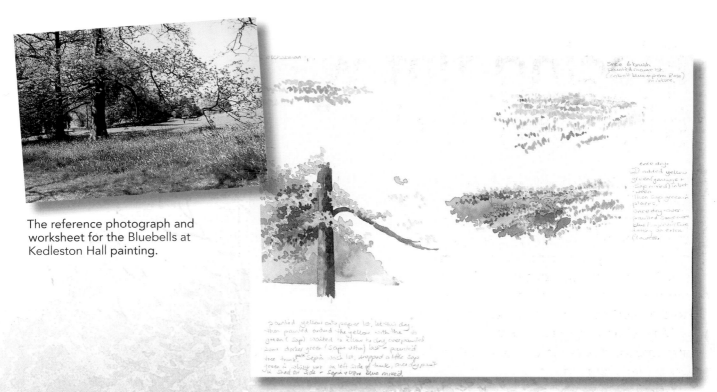

The reference photograph and worksheet for the Bluebells at Kedleston Hall painting.

Details from Bluebells at Kedleston Hall.

Bluebells at Kedleston Hall

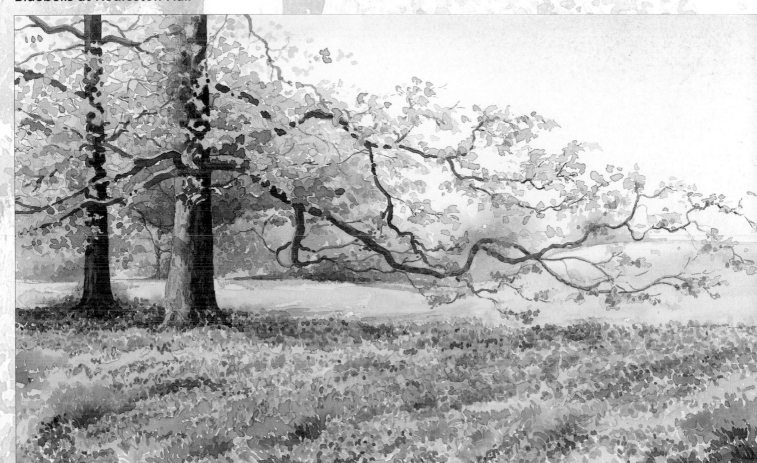

Skies

This simple sky forms the basic structure for more complicated skies. As there are no hard lines or outlines in a sky, I always wet the paper first. This allows the blue paint to flow across the wet surface, emphasising the soft edges of the clouds. Before I paint the sky area in my painting, I find it useful to practise on some lining paper. It is important to mix large washes of colour first and test them out on a piece of scrap paper.

Sky with hedge

Before beginning to paint, prepare a mix of cerulean and ultramarine for the sky and lighter and darker mixes of new gamboge and ultramarine.

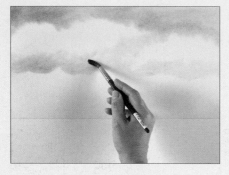 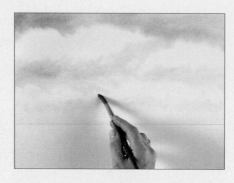

1 Wet the sky area. Use the no. 10 brush to brush on the blue mix across the top, leaving white shapes for clouds.

2 Use a weaker mix of the blue to paint smaller, fainter clouds closer to the horizon.

3 Wet the brush, dab it on kitchen paper and use it to blend and soften any hard edges. Wet, dab and blend repeatedly.

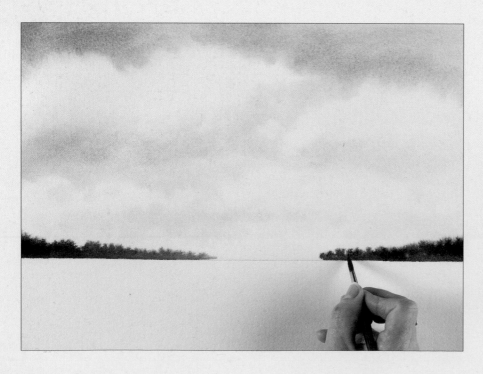

4 Use the no. 6 brush and a thick, dark green mix to paint the distant hedge above the horizon line, wet in wet.

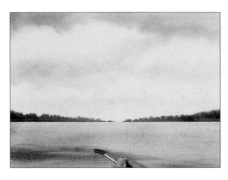 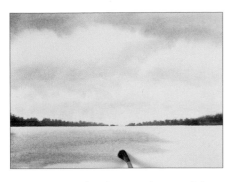 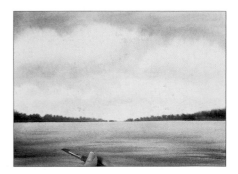

5 Allow the hedge to dry. Wet the grass area and paint in a lighter green mix with horizontal strokes.

6 Brush in the darker green mix wet in wet.

7 Add more ultramarine to the green mix and brush this in from the edges and at the bottom.

The finished painting.

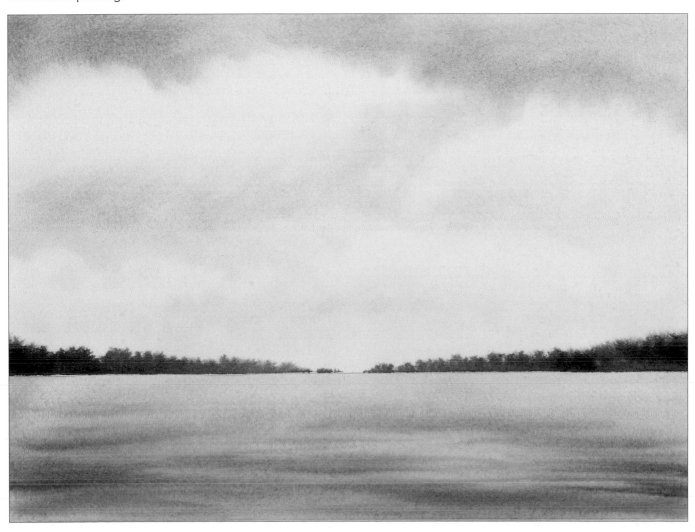

Sky with breakwater

Mix your initial washes first: ultramarine, alizarin crimson and a tiny bit of new gamboge for clouds, cobalt blue for the sky and a thick mix of ultramarine and raw sienna for the distant hedgerow.

1 Wet the sky area thoroughly once, then again. Paint the sky with a no. 10 round brush and cobalt blue, leaving cloud shapes. Make the clouds smaller towards the horizon.

2 Working quickly wet in wet, paint the cloud mix on the undersides of the clouds.

3 Blend in the darker areas of the clouds using a clean, damp brush.

4 Paint in the distant hedge, wet in wet. Allow to dry.

5 Wet the area of distant water and paint in the sea colour, ultramarine with a touch of raw sienna. Allow this to dry.

6 Prepare all the washes for the next wet in wet section, up to step 14. Wet the beach area and paint it with raw sienna with touches of alizarin crimson and ultramarine.

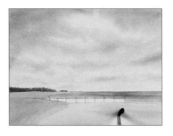

7 Paint the shallow water with ultramarine and a touch of raw sienna.

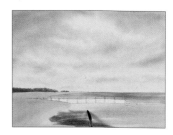

8 Paint ultramarine, alizarin crimson and new gamboge on to the area of rocks and seaweed, and blend this in wet in wet with the shallow watercolour.

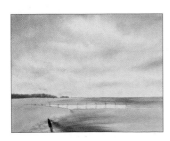

9 Use the tip of the brush to paint the textured area at the edge of the beach.

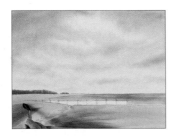

10 Paint shadow on the beach with a darker mix of the beach colours, raw sienna with alizarin crimson and ultramarine.

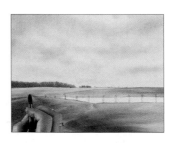

11 Use the same dark mix to suggest details in the distant sand.

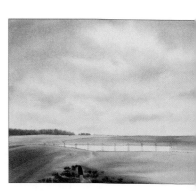

12 Use a darker mix of the rock and seaweed colours, ultramarine, alizarin crimson and new gamboge to paint texture in this area, working wet in wet with the point of the brush.

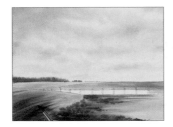
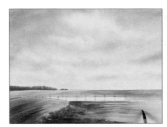
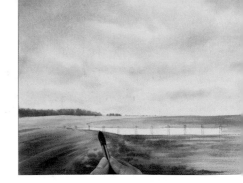

13 Paint the shadow under the breakwater, then continue adding texture.

14 Use the same dark mix to paint shadow from the left-hand side over the sand.

15 Use dry brush work to paint the same mix in horizontal strokes over the dried background sea.

16 Paint shadow on the sand from the breakwater with the same mix and allow the painting to dry.

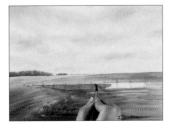
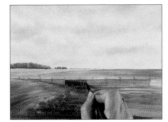
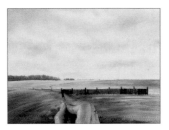
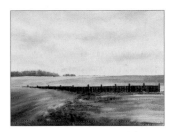

17 Change to a no. 6 round brush and paint a flat wash on the breakwater of the paler cloud mix of ultramarine, alizarin crimson and a tiny bit of new gamboge.

18 Use a darker mix of the same colours to paint vertical strokes for wooden slats.

19 Use a darker mix still to reinforce the darks in the breakwater.

20 Use the point of the no. 6 brush to paint texture, suggesting seaweed and rocks.

The finished painting.

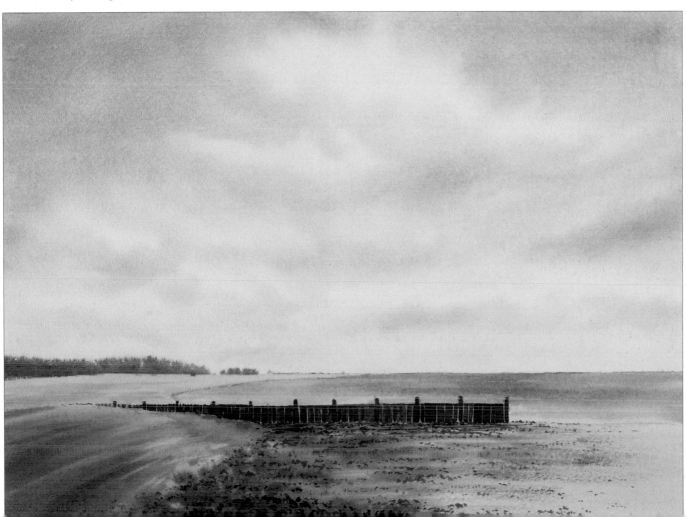

Demonstrations

These two demonstrations are the culmination of all the techniques featured on previous pages: colour mixing, wet-in-wet washes, sponging textures and masking highlights and flowers.

The demonstrations show two very different approaches to watercolour painting. I hope you will enjoy attempting them both.

In the first demonstration, Old Cottage, I have broken the picture down into easy stages, starting with the sky and working from top to bottom so as not to smudge any wet paint. Each section is painted carefully and left to dry before moving on to the next stage.

The second demonstration, Autumn Lane, is painted in a very different style to the cottage scene. It can be daunting to look at your detailed drawing on a white sheet of paper and wonder if are you about to 'spoil it', but my advice is not to worry about how the painting will turn out and to enjoy the immediacy of this painting process. Working far more quickly than on the previous picture, large puddles of bright-coloured washes are mixed and brushed across the entire piece of wet paper. I had great fun dropping in the rich colours to give the impression of leaves glowing in the sunshine.

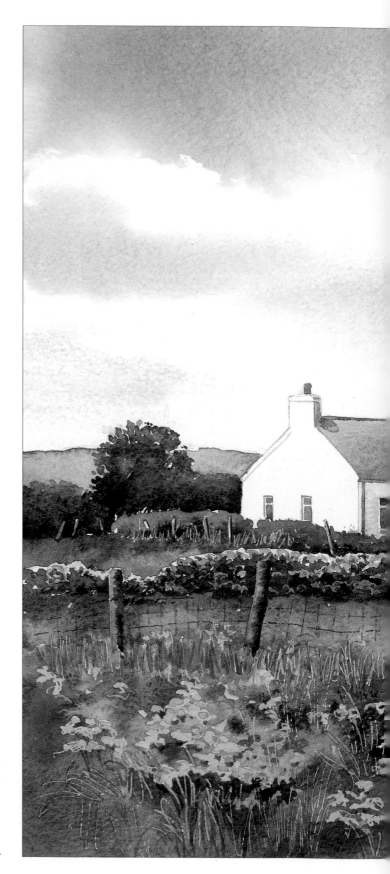

Anglesey Cottages
40.5 x 29cm (16 x 11½in)

This lovely row of cottages sit close to the sea, on the edge of a small shingle beach in Anglesey, North Wales. Only a short walk across the headland from Moelfre, this exact view is not quite visible from the path and I had to stand on a wall to take the reference photograph for this painting.

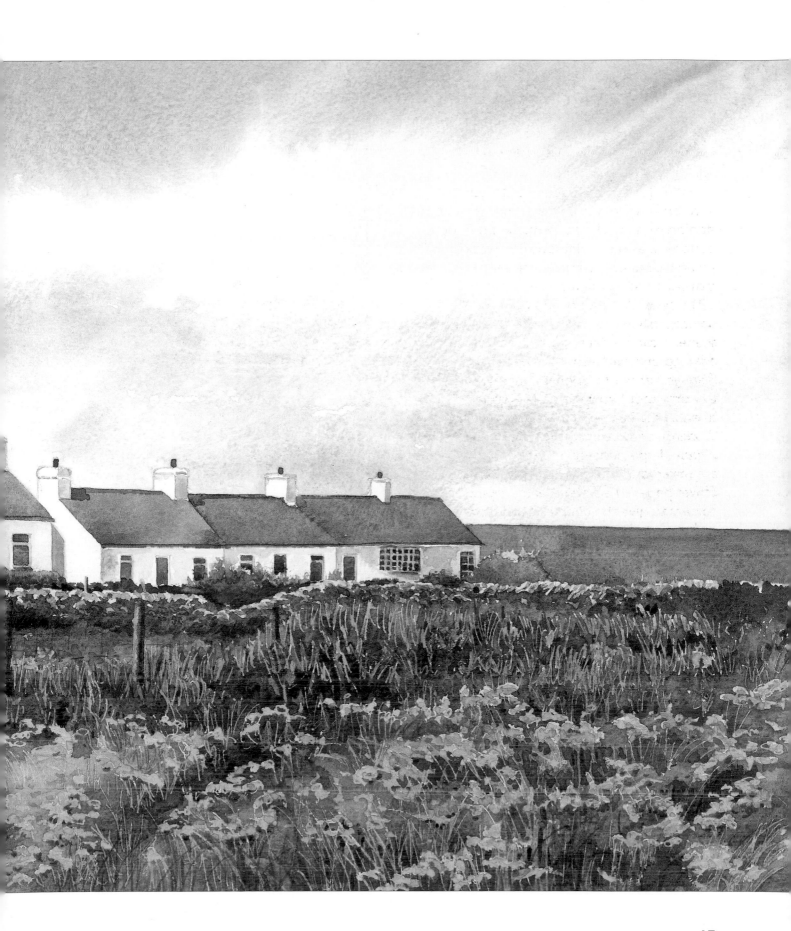

Old Cottage

I came across this wonderful crumbling cottage whilst on holiday in Wales. Trees towered over it and a beautiful yellow gorse bush engulfed the textured walls – I immediately wanted to capture its charm.

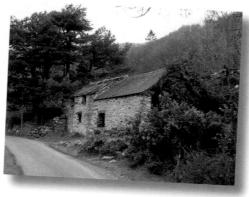

The reference photograph.

You will need

300gsm (140lb) Not finish cotton paper, 28 x 38cm (11x15in)

Watercolour paints: cadmium red, ultramarine, new gamboge, cerulean blue, raw sienna, cadmium red deep, indigo, burnt sienna

Paint brushes: no. 12, no. 10, no. 6 and no. 1 round

Masking fluid, colour shaper and ink pen

1 Make two mixes of cadmium red, ultramarine and new gamboge for the hazy distant trees, one browner and one bluer. Also mix a pale green for behind the trees on the left from new gamboge and ultramarine, and a weak wash of ultramarine with a tiny bit of cerulean blue for the sky. Test the colours on wetted watercolour paper.

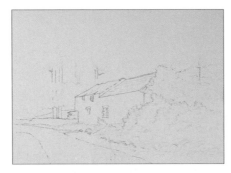

2 Use the colour shaper to apply masking fluid to the gorse flowers, and the top of the roof and add dots on the bush behind the gorse. Use an ink pen to apply it to the dried undergrowth in the foreground.

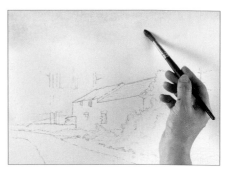

3 Thoroughly wet the paper down to the left-hand bank and the roof, using a no. 12 brush. Take a no. 10 brush and apply the weak sky mix from the top.

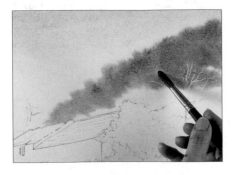

4 Apply the hazy tree mix on the right, wet in wet.

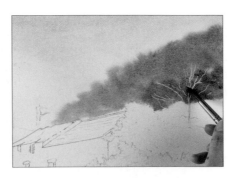

5 Drop in the slightly stronger, bluer mix of the same colours at the bottom.

6 Drop in the pale green mix on the left as a backdrop for the trees. Allow to dry.

7 Make a roof mix from ultramarine and cerulean blue with a little cadmium red, and a warmer mix of raw sienna and cadmium red deep. Paint the roof with the first mix on the no. 6 round brush.

8 Paint the left-hand roof in the same way, then while it is wet, drop in the warmer colour at the bottom edge. Allow to dry.

9 Make a lighter and a darker mix of new gamboge and indigo. Rewet the left-hand tree area with the no. 12 brush and very clean water, up into the sky. Leave the paper until it is just damp and dab on foliage with the lighter mix.

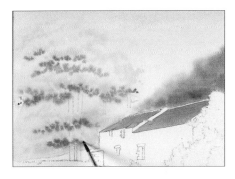

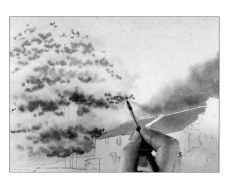

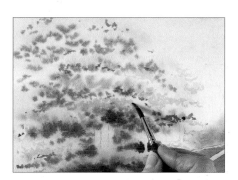

10 Drop in the darker green mix wet in wet beneath the clumps of foliage.

11 Add more indigo to darken the mix further and dab this on for the darkest parts of the foliage. Leave spaces for glimpses of trunks and branches. Allow to dry.

12 Now working wet on dry, add in extra leaves with the lighter green on the tip of the no. 6 brush.

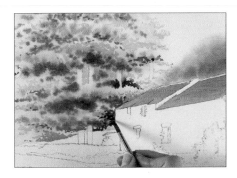

13 Add still more indigo to the green mix to paint darker foliage to bring out the lighter edges of the cottage. Allow to dry.

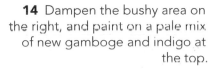

14 Dampen the bushy area on the right, and paint on a pale mix of new gamboge and indigo at the top.

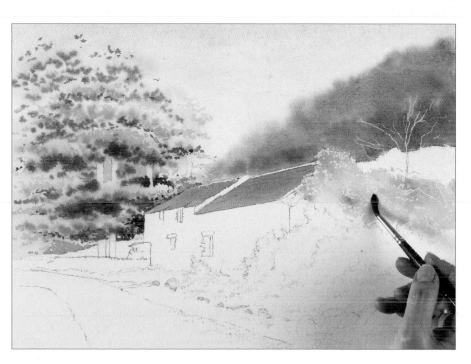

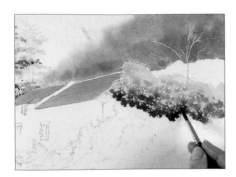

15 Drop in a darker mix of the green at the bottom of the bush, working wet in wet.

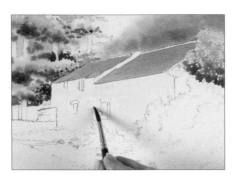

16 Dampen the front of the cottage with clean water, then drop in a weak wash of raw sienna here and there.

17 Change to the no. 1 brush and drop in the bluer hazy trees mix of cadmium red, ultramarine and new gamboge in places.

18 Darken under the eaves with the same mix and continue adding texture to the cottage walls.

19 Paint the wall in the same way as the cottage front: dampen it, drop in raw sienna and then drop in the bluer hazy trees mix with the no. 1 brush.

20 Rub off the masking fluid from the top of the roof and use the no. 1 brush to paint a pale mix of the roof colour, ultramarine and cerulean blue with a little cadmium red.

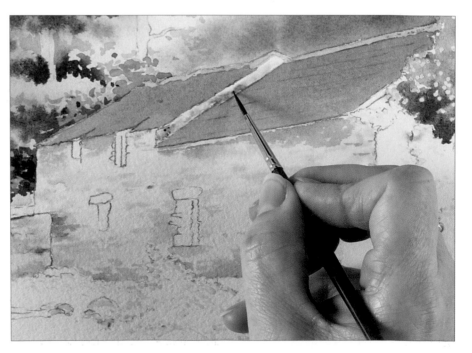

21 Use the no. 6 brush to dampen the wall showing between the roofs. Drop in the weak raw sienna wash, then the bluer hazy trees mix with the no. 1 brush.

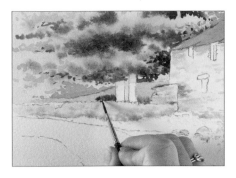

22 Paint the grass behind the wall with the no. 6 brush and a pale mix of new gamboge with ultramarine. Drop in a darker mix of the same colours with the no. 1 brush just above the top of the wall. Allow to dry.

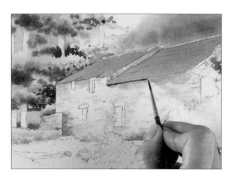

23 Continue adding detail to the cottage walls with the no. 1 brush and the bluer hazy trees mix. Paint the shadow under the eaves with a darker mix.

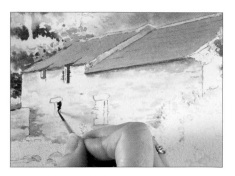

24 Use the same darker mix to paint the windows. Allow to dry.

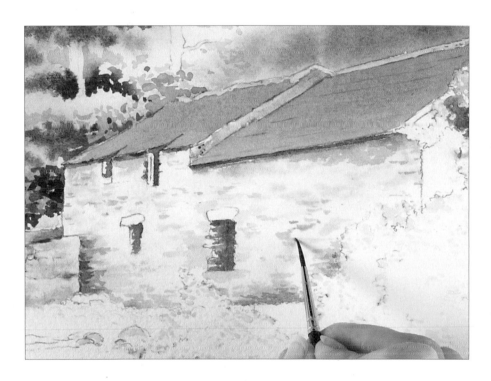

25 Paint in a few details of stonework wet on dry using the paler hazy trees mix and the no. 1 brush.

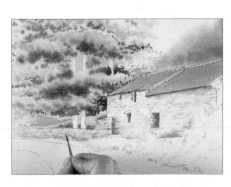

26 Add detail to the wall in the same way.

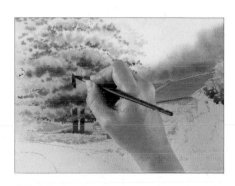

27 Mix burnt sienna and ultramarine and use the no. 6 brush to paint the tree trunks from the bottom upwards, leaving gaps for foliage.

28 Change to the no. 1 brush to paint glimpses of more distant trunks and thinner branches, always working from the bottom upwards.

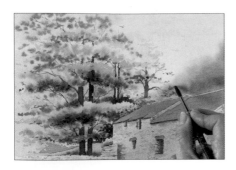

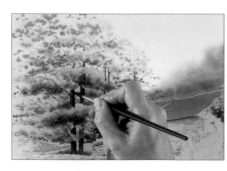

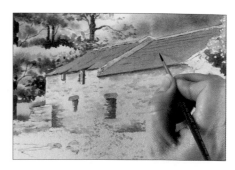

29 Use a dark mix of new gamboge and indigo on the no. 6 brush to paint the undersides of clumps of foliage, and to define a few individial leaves. Add some leaves to the ends of branches.

30 Shade the right-hand sides of the larger tree trunks with a darker mix of burnt sienna and ultramarine on the no. 6 brush.

31 Use the no. 1 brush to paint details of roof tiles with a darker mix of the roof colours: ultramarine and cerulean blue with a little cadmium red.

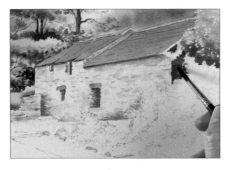

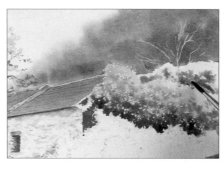

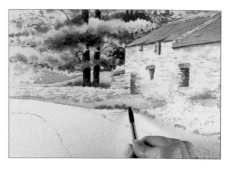

32 Paint the shadowed side of the cottage with the no. 6 brush and a dark mix of the hazy trees colour: cadmium red, ultramarine and new gamboge. Break up the edges of the area to suggest foliage.

33 Wet the area behind the green bush on the right, and paint on a weak wash of raw sienna, then drop in the hazy trees colour.

34 Dampen the grass area in front of the wall and paint in new gamboge and ultramarine, then drop in a darker mix at the bottom.

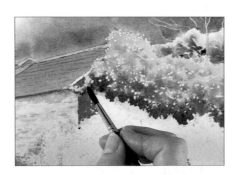

35 Fill in the area of the right-hand bush that crosses the shaded cottage wall, with new gamboge and indigo.

36 Prepare washes: new gamboge; new gamboge and ultramarine; and a thick, dark green mix of new gamboge, lots of ultramarine and a touch of burnt sienna. Also make a darker version of the hazy trees colour, cadmium red, ultramarine and new gamboge. Dampen the area of the gorse bush and paint on new gamboge for gorse flowers.

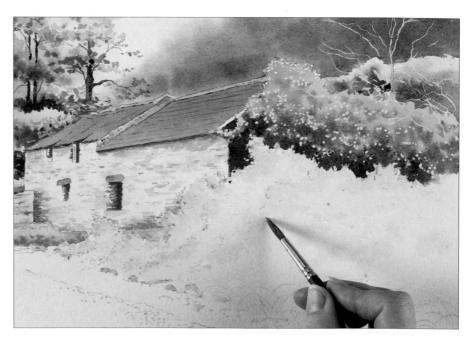

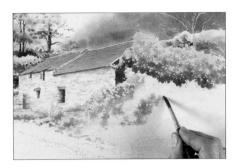

37 Touch in the green mix of new gamboge and ultramarine wet in wet.

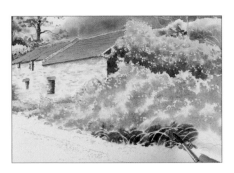

38 Paint the browner of the hazy trees mixes (cadmium red, ultramarine and new gamboge) at the bottom.

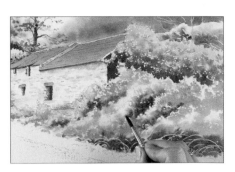

39 Still working wet in wet, paint in the dark green mix behind the yellow of the gorse bush to bring it out and suggest clumps of gorse. Allow to dry.

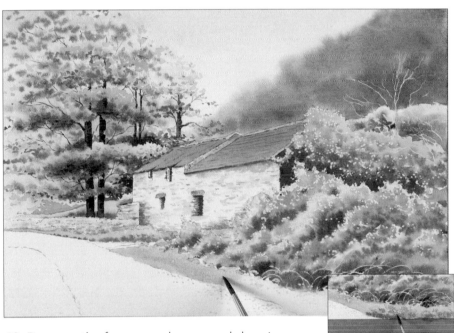

40 Dampen the foreground grass and drop in new gamboge and ultramarine. Drop in the thicker, darker green wet in wet.

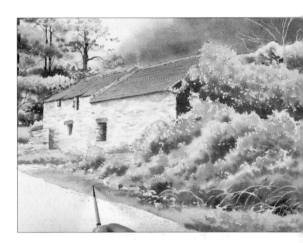

41 Add detail to the grassy area with the no. 1 brush and the same darker green.

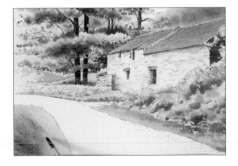

42 Dampen the area of the left-hand foreground and paint in the lighter mix of new gamboge and ultramarine with the no. 6 brush. While this is wet, drop in the darker green for shadow.

43 Paint distant branches behind the cottage and on the right of the painting with the point of the no. 1 brush and a mix of burnt sienna and ultramarine. As always with trees, work from the bottom upwards.

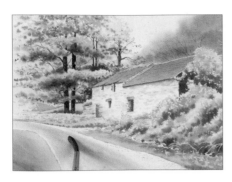

44 Paint shadow on the path with a watered down wash of the roof mix, ultramarine and cerulean blue with a little cadmium red on the no. 10 brush.

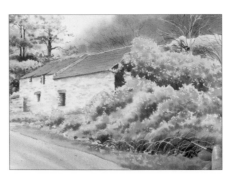

45 Paint twigs in the undergrowth in front of the gorse with the browner hazy trees colour, cadmium red, ultramarine and new gamboge, on the no. 1 brush.

46 Rub off all the remaining masking fluid with clean fingers.

47 Use the no. 1 brush to fill in the pale twigs in the distant trees with the same very watery hazy trees mix. It must be lighter than the background.

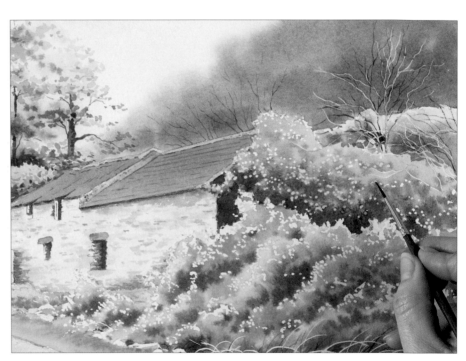

48 Use a very watery mix of new gamboge and indigo on the no. 1 brush to fill in the masked dots on the right-hand green bush.

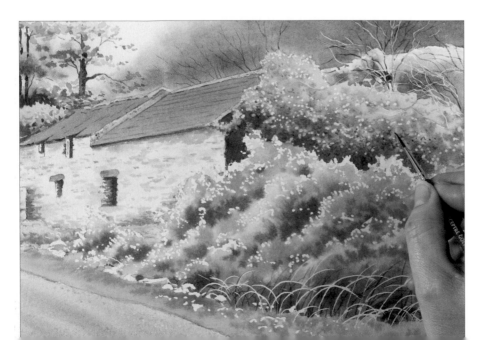

49 Paint darker texture in the bush with a darker mix of new gamboge and indigo and the tip of the no. 1 brush.

50 Enhance the yellow gorse flowers by painting on more new gamboge wet on dry.

51 Fill in the lighter masked twigs in the undergrowth with a pale wash of the browner hazy trees mix: cadmium red, ultramarine and new gamboge.

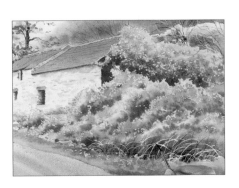

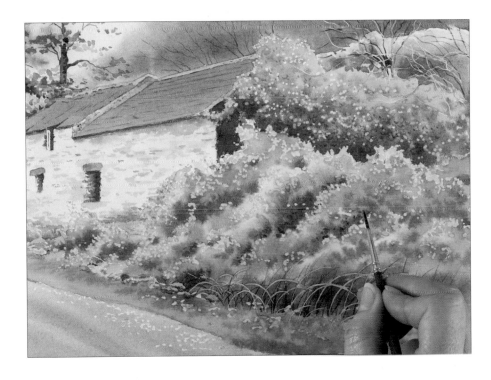

52 Add dark green detail to the gorse bush with new gamboge and indigo on the tip of the no. 1 brush.

53 Shadow the pebbles on the road with a dark mix of the hazy trees colour, cadmium red, ultramarine and new gamboge.

54 Add detail to the tree with the no. 6 brush and a mix of new gamboge and indigo.

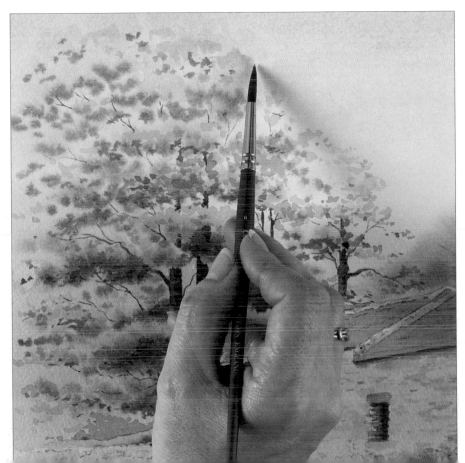

Old Cottage

28 x 38cm (11 x 15in)

As well as landscape pictures of trees and fields, I like to include crumbling cottages and rambling buildings with lots of character in my paintings. In this picture I have tried to suggest the texture of the stone cottage walls by using wet in wet washes rather than painting in every individual stone.

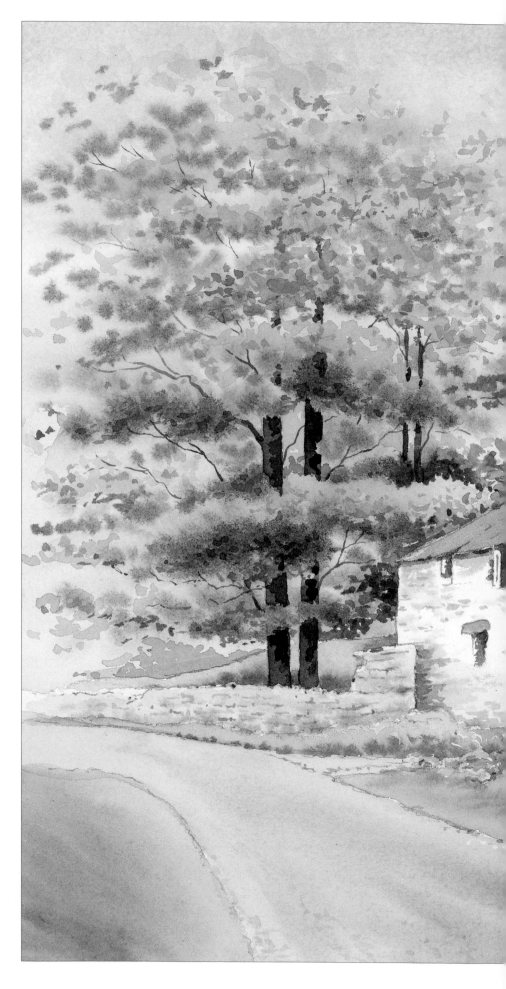

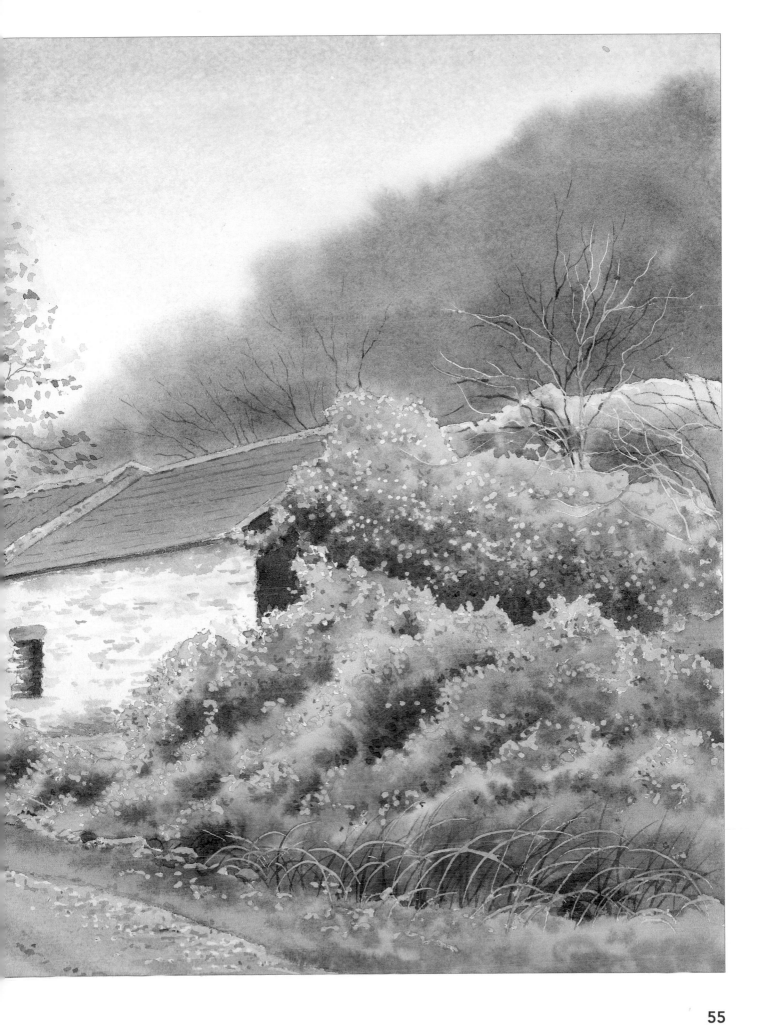

Autumn Lane

There is very little drawing in this scene apart from on the top of the distant wall to the left, the curve of the path and the top of the bracken. The trees, banking and path are all suggested with the colour as one wash fuses into the next.

It is important to prepare a fairly large quantity of paint. Add plenty of pigment to the washes, making them the consistency of single cream, or the colours will dry very pale.

The reference photograph.

You will need

Paper: 300gsm (140lb) Not finish cotton paper, 28 x 38cm (11 x 15in)

Watercolour paints: new gamboge, raw sienna, burnt sienna, alizarin crimson, ultramarine blue

Paint brushes: no. 12, no. 10, no. 6 and no. 1 round

Masking fluid, colour shaper and ink pen

Natural sponge

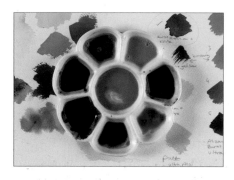

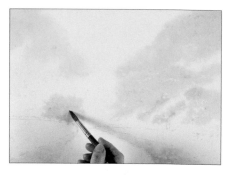

1 Prepare initial washes of: new gamboge and raw sienna; raw sienna and burnt sienna; burnt sienna and alizarin crimson; a thicker mix of alizarin crimson, burnt sienna and ultramarine for a dark plum colour; a light green from new gamboge and ultramarine; a dark green from ultramarine and a little new gamboge; a very thin sky wash of ultramarine; and a watery mix of ultramarine, alizarin crimson and a touch of new gamboge for the lane.

2 Draw the scene. Use the tip of the colour shaper to apply masking fluid to the highlighted leaves and the fallen leaves, then use the ink pen to mask a few grasses and the top of the wall on the left-hand side.

3 Wet the whole paper with the no. 12 round brush and clean water, then wet it again. You will be working wet in wet for the first part of the painting. Drop in new gamboge and raw sienna with the no. 10 brush.

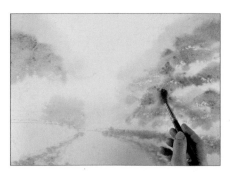

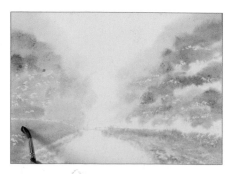

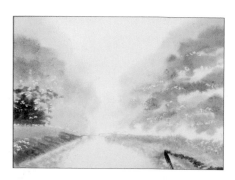

4 Working wet in wet, apply burnt sienna and raw sienna, using the flat of the brush.

5 Still working wet in wet, apply the lighter green.

6 While this is wet, apply the darker green as shown.

7 Paint on the pale ultramarine wash for the sky, going up to just short of the yellow.

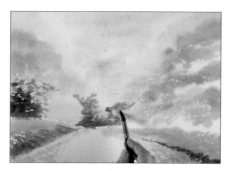

8 Add more dark green at the end of the lane, continuing to work wet in wet.

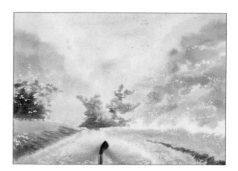

9 Paint the grey wash on the lane.

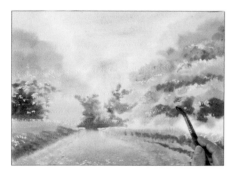

10 Apply the deeper orange mixed from burnt sienna and alizarin crimson to the trees and the bracken on the right-hand side of the lane.

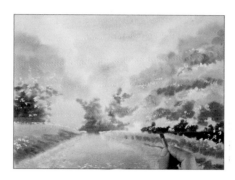

11 Paint the deep plum colour behind the bracken.

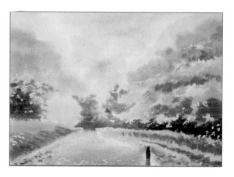

12 Add texture to the fallen leaves on the lane with the burnt sienna and alizarin crimson mix.

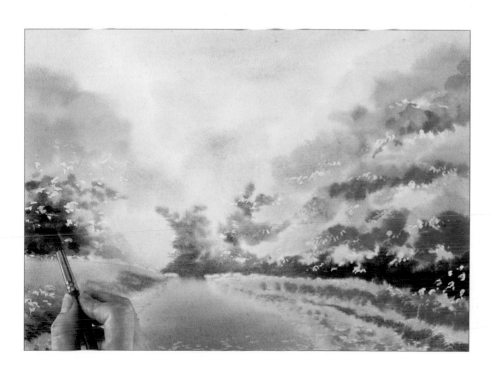

13 Apply more of the dark green.

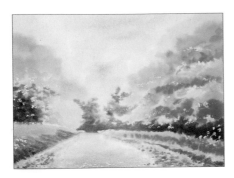

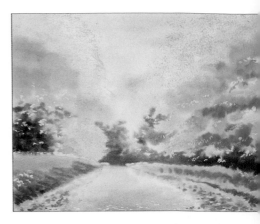

14 The colours should all have merged slightly on the damp paper. Now allow the painting to dry naturally. The colours should continue to spread a little until the painting is dry, so do not speed up the drying process with a hairdryer.

15 Pick up raw sienna and new gamboge on a natural sponge. Practise dabbing the paint on to a spare piece of paper, then dab it gently on to the trees to create the texture of foliage. The colour should be one tone darker than the background.

16 Continue sponging over the trees, extending the texture slightly into the sky. Allow to dry.

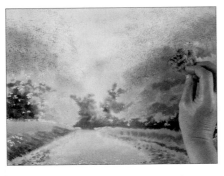

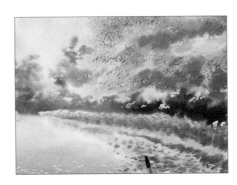

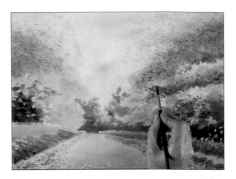

17 Now continue sponging wet on dry with the raw sienna and burnt sienna mix.

18 Use the point of a no. 6 brush to build up the detail of the fallen leaves with raw sienna and burnt sienna.

19 Add leaf shapes in the trees with the same mix and technique.

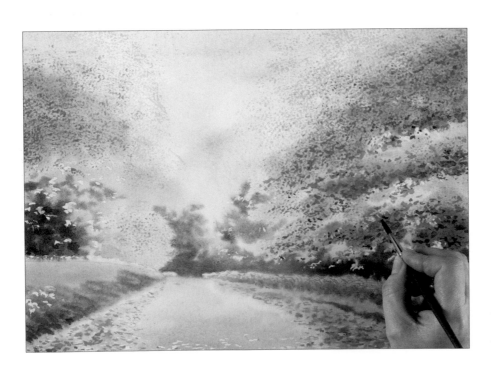

20 Use the alizarin crimson and burnt sienna mix to add further texture to the trees.

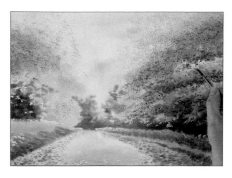

21 Add detail to the green areas of the trees with the new gamboge and ultramarine mix.

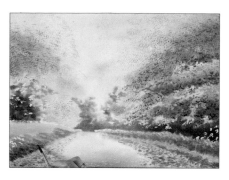

22 Build up the texture in the grassy area on the left using the darker green.

23 Return to the lighter green to add texture to the yellow bush.

24 Paint grasses on the right-hand verge with the no. 1 brush and the dark green. Allow to dry.

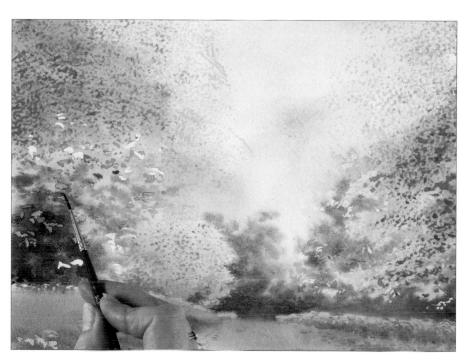

25 Rub off the masking fluid on the left of the painting with clean fingers. Fill in a few of the leaves with the no. 1 brush and the new gamboge and raw sienna mix.

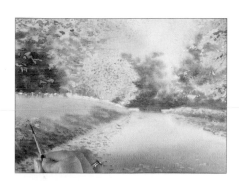

26 Fill in the leaves coming in from a bush to the left-hand side of the scene, still using the new gamboge and raw sienna mix.

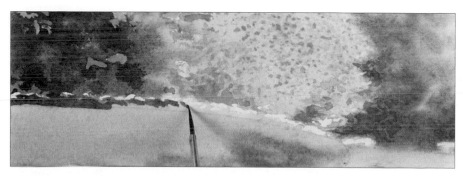

27 Mix burnt sienna and ultramarine to paint the stone wall in the middle distance. Use the no. 1 brush and leave the top of the wall white for highlights.

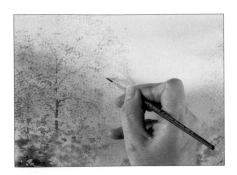

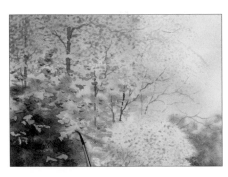

28 Use the same brush and mix to paint distant tree trunks and branches. Start at the bottom and paint upwards, and use paler paint for the finer twigs.

29 Pick up the dark green on the same brush and use it to add little dashes of detail to the green foliage, to highlight the lighter areas and to add pattern.

30 Look at the textures and patterns of the painting at this stage to see what needs to be added. I have done some more sponging with the new gamboge and raw sienna mix.

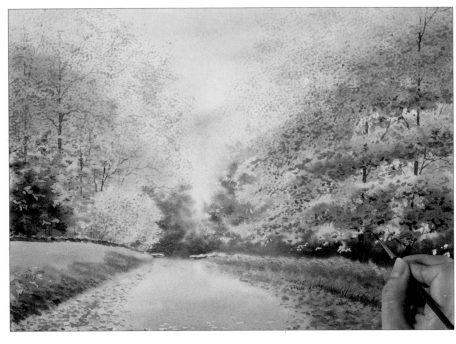

31 Use the burnt sienna and ultramarine mix to paint the trunks and branches of the trees on the right. Some of these are further forwards than the left-hand trees, so they should be darker. Start from the bottom and paint upwards, leaving gaps where the foliage hides the trunks and branches. Allow to dry.

32 Remove the masking fluid from the right-hand side. Use the no. 1 brush and a mix of burnt sienna and raw sienna to paint the leaves coming in from the right-hand side, in front of the plum colour.

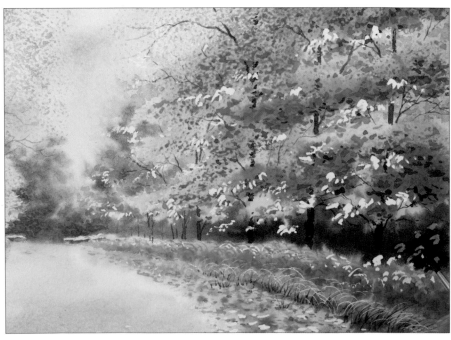

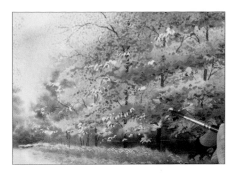

33 Paint the leaves that were masked out with new gamboge and raw sienna.

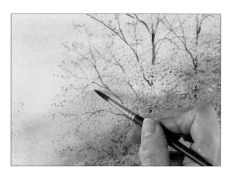

34 Add leaves on the ends of branches with the same mix.

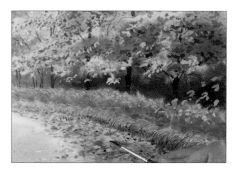

35 Add a few darks to the fallen leaves in the foreground with the burnt sienna and alizarin crimson mix on the no. 1 brush.

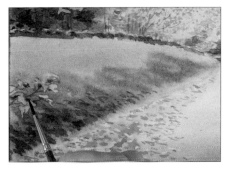

36 Shade the leaves coming in from the left-hand side with the same mix.

37 Take the no. 10 brush and a thin wash of ultramarine and alizarin crimson and glaze this across the lane for shadows. Allow to dry.

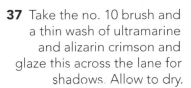

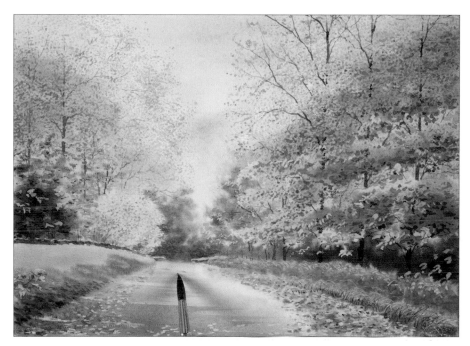

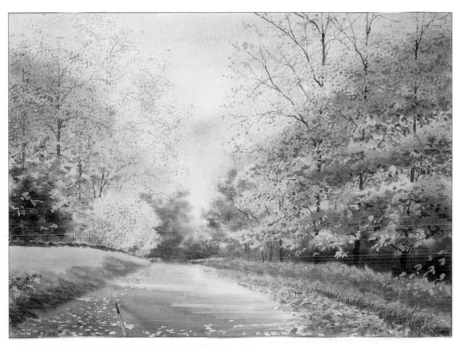

38 Rub off the masking fluid on the lane and fill in the fallen leaves with a thin mix of raw sienna and burnt sienna on the no. 1 brush.

Autumn Lane

28 x 38cm (11 x 15in)

It is not always possible to take photographs of a scene on a sunny day but we can suggest sunshine in our paintings by making colours brighter and painting shadows across the path as I have in this picture.

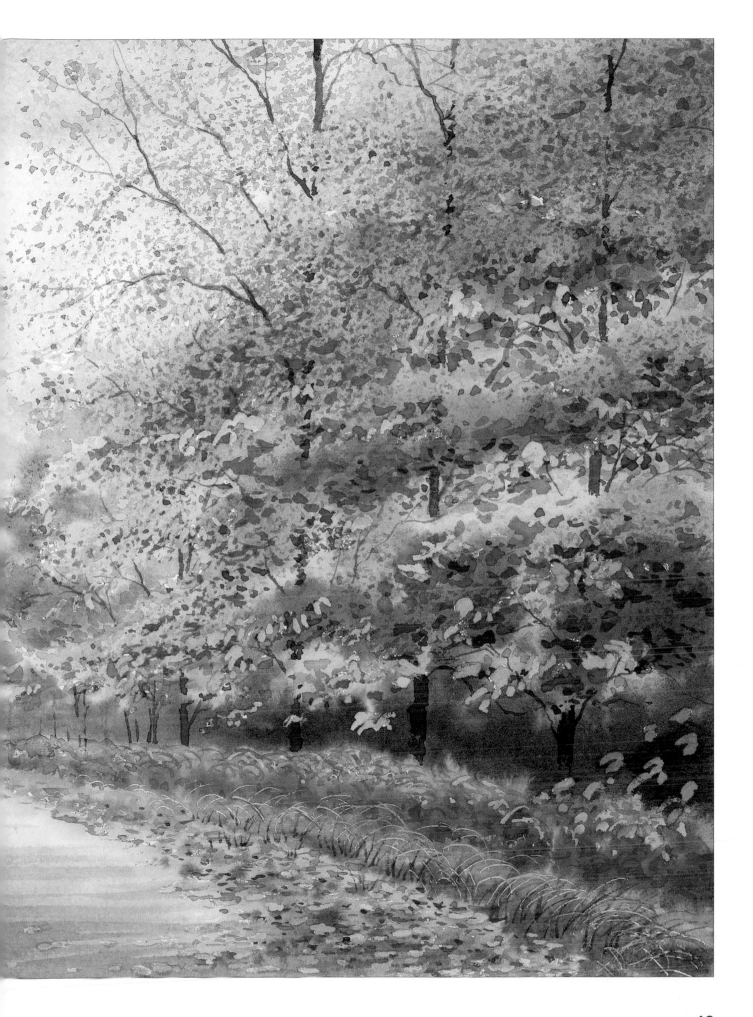

Index

Red Sunset
35.5 x 25.5cm (14 x 10in)

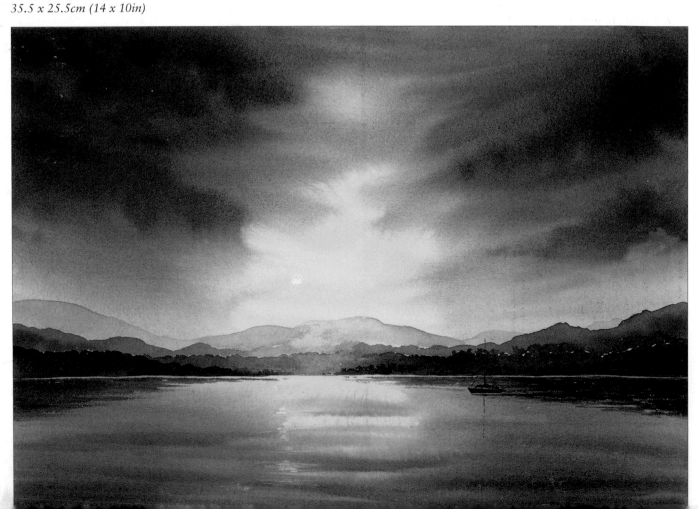